Nashville
Public Library
Foundation

*Books and other materials
on photography
made possible
through the generosity of*
Colleen Black

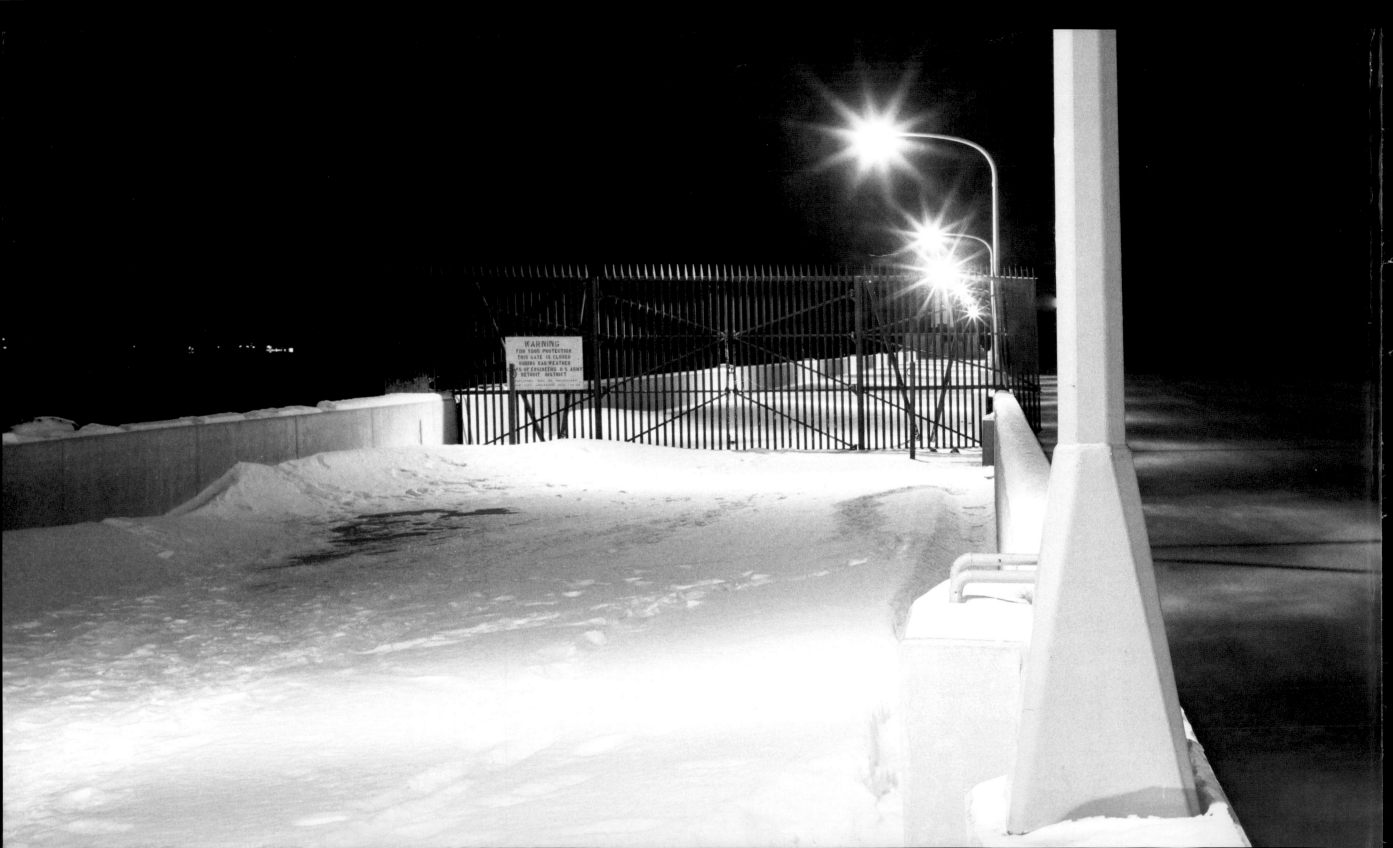

Nocturnes

Chris Faust

WITH AN ESSAY BY JOAN ROTHFUSS

University of Minnesota Press
Minneapolis • London

The University of Minnesota Press gratefully acknowledges financial assistance provided for the publication of this book by the Jerome Foundation.

Published by the University of Minnesota Press
111 Third Avenue South, Suite 290
Minneapolis, MN 55401-2520
http://www.upress.umn.edu

Book design by Brian Donahue / bedesign, inc.

Library of Congress Cataloging-in-Publication Data

Faust, Chris.
Nocturnes / Chris Faust ; with an essay by Joan Rothfuss.
 p. cm.
Includes bibliographical references.
ISBN 978-0-8166-5016-3 (hc/j : alk. paper)
1. Faust, Chris. 2. Night photography. 3. Landscape
photography. I. Rothfuss, Joan. II. Title.
TR610.F39 2007
779'.36--dc22
 2006101633

Printed in China on acid-free paper

The University of Minnesota is an equal-opportunity educator and employer.

15 14 13 12 11 10 09 08 07 10 9 8 7 6 5 4 3 2 1

Contents

NIGHTWATCH

On the Photographs of Chris Faust

joan ROTHFUSS

Prelude

We arranged to meet in a parking lot in northeast Minneapolis at seven o'clock in the evening. It's early January, and the snow that's left after a weeklong thaw has an icy sheen under the streetlights. Chris Faust arrives wearing a hooded parka and fleece-lined cap with long earflaps that Velcro under his chin: standard gear for anyone who works outside in the Minnesota winter, even on a mild night like this one. He shoulders a small bag of camera equipment, tucks a tripod under his arm, and sets out in the dark to photograph the neighborhood.

He has been making night images since 1988. He's covered just about every corner of the state by now, but tonight he's sticking close to home and I've asked to tag along to observe his process. Our first stop is a house that someone has sheathed in stainless steel panels, an oddity that Faust had spotted on previous drives through the area. The home's funhouse-mirror façade is alive with reflections from the lights on a fire station across the street. Faust assesses the scene quickly and positions his tripod to frame the house from an oblique angle so that he can also include a tree down the block that is still strung with Christmas lights. While I wait, I study the house. It's dark inside, and I wonder who owns it and what they would think if they came home right now. We aren't trespassing, here on a city sidewalk, though finding someone aiming a camera at your house under cover of darkness could kindle anyone's latent paranoia. *Do you ever go up and ring the doorbell to ask permission when you're making photographs like this?* No, he doesn't. *Have you ever been asked to leave a place?* Only once, when he was working on railroad property—a bored yard boss who needed something to do, he figures. The city cops never bother him, although passing squad cars usually slow down to check him out. He rarely feels in danger while he's working.

No one is on the street this evening, and Faust works with a relaxed concentration, chatting with me about what he's doing as he twists a lens onto his camera (he isn't using his trademark panoramic camera tonight, but a Hasselblad, which makes square negatives). He typically avoids using a flash, preferring to stick with available light, and he doesn't use a light meter. For this picture he guesses that he will need a five-minute exposure, which he times with a small, inexpensive digital clock he pulls out of his parka. He doesn't bracket his exposures, but takes only one shot of each subject; this means he has only one chance to get it right, but after fifteen years of working at night he's grown confident in his ability to read the light. Anyway, he assures me, success doesn't hang on precision. Give or take a few seconds in either direction, and you'd still be fine. Someone could walk in front of the lens during the exposure and never show up in the picture. It occurs to me that Faust's photographs don't "capture" anything; what they do, instead, is *receive*. They wait, until what is in front of the lens emerges from the shadows; nothing shows up on one of his negatives unless it's stationary or moving very, very slowly. His pictures do not represent the celebrated "frozen moment." They show an aggregation of moments. A while.

The picture of the metal-clad house finished, we wander into the neighborhood. This part of town is a mix of working-

class homes, corner bars, and churches. A century ago, it was populated by immigrants from eastern and southern Europe. Today it's being gentrified, but there are plenty of remnants of its past, like a brick edifice with an enameled sign that reads "Polish White Eagle Association / since 1906." Faust passes it by, hunting for something less nostalgic. He glances up and down alleys as we walk, and eventually stops in front of a nondescript duplex. A three-wheeled electric scooter is parked on its front walk, and an empty Coors can lies on a mound of dirty snow by the street. The driveway is scattered with play money—a couple dozen soggy $10,000 notes, issued by the Heaven Bank. To me, this is just another unremarkable and slightly depressing urban tableau, but Faust finds it "sort of pathetic" in an interesting way, and takes a picture. Next, around a couple of corners, the Lao Buddhist Temple sports a gabled mural of the seated deity and a stairway decorated with elaborately carved and painted serpents, whose flaring tin tongues are trembling in the night breeze. Its interior and exterior are both unlit. *Isn't this too dark to photograph?* No, there's plenty of light, we'll just do ten-minute exposures. He does two of them, from different spots. Twenty minutes. I begin to get bored, and my fingers are numb. *What do you bring along on your shoots, besides camera equipment?* Warm clothes, a flashlight, a watch, and a lot of patience.

Our last stop is the 331 Club, which sits on one corner of a busy intersection. From across the street Faust considers the bar's long side wall, a collage of boarded-up windows, signage, downspouts, wires, and a single doorway. He sets up his tripod as a steady stream of traffic passes by, headlights flaring on the bar's orange wall. *What do you do when cars go by—don't the lights ruin your picture?* He doesn't answer because he is silently counting off the exposure in seconds, covering the lens whenever a car goes by and resuming the count after it's gone. I suppress a smile when I notice his makeshift lens cap: a scrap of cardboard that looks like it was cut from a cereal box.

We usually think of nighttime as dark, but in fact light is everywhere. It's actually hard to get away from light, at least in the city. Windows glow from inside, motion-sensitive security lights flip on and off, streetlights and neon signs and headlights abound. If tonight hadn't been overcast there would have been moonbeams and starlight, too. All this light ricochets off reflective surfaces of all kinds until it seems as if the air itself is illuminated. On my way home I begin to understand that a preoccupation with darkness is not what drives Faust into the night. Rather, it's an infatuation with light.

Chiaroscuro

Faust's art is not confined to night imagery. He describes himself as a landscape photographer, and he has made images of architectural, agricultural, and industrial vistas in both color and black and white. In the 1990s he began a project documenting suburban sprawl and its often-abrupt intrusion on rural areas, and a recent commission took him to Kentucky to photograph the changing Appalachian landscape. Those projects are topical, timely notations on the evolution of the American environment during the past two decades; as Faust has noted, the speediness of the transformation imparts a certain urgency to his work.[1]

Night photographs, however, constitute Faust's most extensive body of work, which he considers an ongoing project. Like his images of suburban expansion, many of his night pictures serve as historical records: they document disappearing agricultural landscapes, outmoded industries, and other aspects of our culture that are quickly fading into irrelevance. The romance of this passage is not the only thing he is attracted to; he also has prowled neighborhoods and thriving commercial districts for images. His night subjects include factories, railroad yards, bridges, docks, and barges; lit signs, lonely farmsteads, bars, gas stations, truck stops, and alleys; rivers, bluffs, frozen lakes, and the vast expanses of the upper Midwestern prairie. His real affection is not for any one subject, but for the way light looks on objects at night. He savors the ambiguities of space and mood that animate the darkness—a complex web of truths, lies, and insinuations that evaporates in the full, clear light of day. In other words, Faust is enamored of how light transforms objects at night, from twilight until dawn.

Growing up, Chris Faust hadn't planned to be an artist. His boyhood obsessions included model rockets, ham radio, microscopy, and telescopes, and he wanted to become a scientist. One of his proudest accomplishments as a teenager was achieving (with the help of an adult friend) a "moon bounce," in which radio waves from an earth-based transmitter were reflected off the surface of the moon back to an earth-based receiver. At St. Cloud State University he majored in biology, and he went on to graduate school at the University of Wisconsin to study aquatic toxicology. He had a student job at the National Fishery Research Lab testing the effects of toxins on freshwater smelt, and he taught himself darkroom

Hugh McKenzie, *Unloading Coal at Boston Coal Docks, Duluth, Minnesota*, 1907. Library of Congress Prints and Photographs Division.

techniques so he could catalog insects by photographing them and studying the enlarged images.

Somewhere along the way, he realized that he was tired of simply collecting data, so he changed course and began working toward a career as a scientific photographer. His first job out of school was a yearlong internship in a children's hospital, where he learned versatility as a kind of jack-of-all-photos: he recorded the progress of skin grafts on patients in the burn ward; made images of spinal deformities and surgical procedures that could be used as teaching tools; photographed victims of child abuse for documentation in legal cases. Next was a job assisting University of Minnesota faculty by crafting images for their research, papers, presentations, and lectures.

Then, in 1986, he was diagnosed with a benign pituitary tumor, which required immediate surgery in a "hot zone" near several major nerves leading to his brain. Life as he had known it was suspended for a time, and after the successful conclusion of the surgery he felt he had "dodged a bullet" and had an obligation to himself to rethink his life course. Ultimately, he decided to dedicate himself to art—a more open-ended way of investigating phenomena, he felt, than that offered by the traditional scientific method. He chose a medium he already knew well: photography.

He was immediately drawn to panoramas—wide, detailed images that present much more information than can normally be seen at once with the naked eye. Panoramic cameras were developed in the nineteenth century and historically are associated with both the spectacular and the documentary. Photographers used the new technology to produce dazzling overviews of cities and landscapes that were rapidly being transformed by urbanization and the industrial revolution. Like the painted dioramas that drew crowds at popular entertainments of the era, panoramic photographs provided an enhanced, God's-eye view of the world that was both instructive and intoxicating.

Faust has said that he adopted the panoramic format because it was "so suited to the open Midwestern landscape" that he wanted to photograph.[2] But the format is old-fashioned, unwieldy, and complicated, and not much in vogue with contemporary artists. His delight in scientific wizardry and mechanical gadgets may have played a part in his choice, but in any case the panorama has turned out to be well suited to his night work, an unhurried activity in which bulky equipment is not a hindrance. In fact, there is in Faust's working style a whiff of the nineteenth century, when itinerant photographers with wagonloads of equipment rattled along country lanes, and artists hauled their easels and paint boxes out of the studio to work in the open air.

Knowing his affinity for old-world practices and tools, it is no surprise to learn that his night series was inspired by the work of a painter. The city- and townscapes of Minnesota artist Mike Lynch are masterly evocations of places and moments that often go unnoticed but still seem utterly familiar to any Midwesterner: a deserted small-town Main Street at twilight, or a bank of concrete grain elevators washed with the weak light of a winter dawn. Faust remembers vividly his first encounter with Lynch's work in the mid-1970s, and he has commented that his night series was motivated partly by a desire to find out whether photographs could render the range of tones and moods that could be achieved in painting.[3]

The histories of painting and photography have been intertwined since the latter's invention in the mid-nineteenth century. Many painters of that time based their compositions on photographic sources, and photographers strove to make their images more "painterly," that is, not strictly dedicated to documentary Truth but also to subjective Beauty. During the first half of the twentieth century, a debate raged about whether images made with a camera could be art and whether painting had been rendered obsolete by the invention of photographic technology. The relationship of the mediums is still a subject of discussion—sometimes heated—among scholars and critics, although the points being debated obviously have shifted with time. Such wrangles, though, are largely inconsequential for artists, who will do as they please and use the medium that

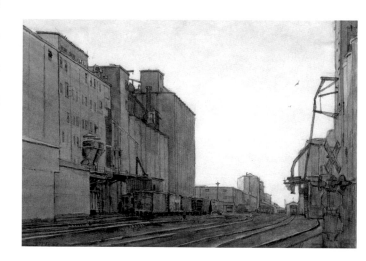

Mike Lynch, *38th and Hiawatha*, 1989. Collection of Kathryn Strom. Reproduced by permission of the artist.

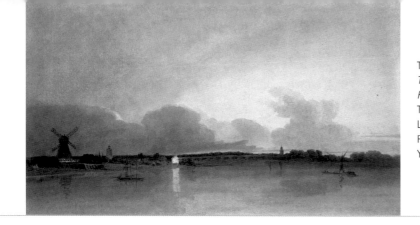

Thomas Girtin, *The White House*, 1800. Tate Gallery, London / Art Resource, New York.

Mark Rothko, *No. 2*, 1963. Collection Walker Art Center, Minneapolis. Gift of the Mark Rothko Foundation, Inc., 1985.

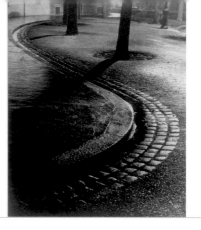

Brassaï, *Le ruisseau serpente* from *Paris by Night*, 1932. Musée national d'art moderne, Centre Georges Pompidou, Paris. Copyright Estate Brassaï—Réunion des musées nationaux, Paris.

suits them, whether or not critics have declared it dead or secondary.

There is a long-standing lyrical tradition in art that celebrates the quiet beauty of the everyday, particularly the landscape. In painting, this includes the pastorals of John Constable and Camille Corot as well as Jean-François Millet's idealized depictions of peasant life and even Edward Hopper's urban nocturnes. These artists share a fondness for the soft, subtle interplay of light and dark; seen in this context, Faust's images can seem utterly painterly. In a photograph like *C&NW Switchyard, Worthington, Minnesota* (1994; Plate 5), the forms emerge from the shadows and snowfall with a softness that recalls the penumbra of Rembrandt or the chiaroscuro of Leonardo. This must be due in part to Faust's preference for ambient light, a choice that necessitates extended exposures of two to twenty minutes in duration, allowing the scene to reveal itself slowly. In this he takes the opposite approach from O. Winston Link, an eccentric who, during the 1950s, used a homemade contraption fitted with dozens of flashbulbs to photograph steam locomotives as they sped through the dark. Although Faust is fascinated by Link's work, his wide-open shutter would never freeze a moving train; instead, he must coax his pictures gradually from the darkness. In contrast to the hint of desperation that lurks beneath Link's complex and methodical technique, Faust is comfortable just recording what happens while time passes. The C&NW switchyard, like many of his subjects, seems cloaked in deep calm. The mood is accentuated by the slowed-down viewing process demanded by a panorama, which must be scanned from side to side to be fully understood.

A more malignant stillness pervades Faust's *House on the Edge of Town, Worthington, Minnesota* (1994; Plate 46). This is the torpid gloom of deep night at its loneliest and most voracious. The buildings perch on the horizon, looking as if they might tumble into the nothingness that stretches out behind them. In other photographs, stillness is countered by a sense of the momentary, conveyed through clouds, mist, smoke, and other fleeting atmospheric conditions. Dusk is settling over the bleak winter landscape in *Dock Slip at Twilight, Thunder Bay, Ontario* (1994; Plate 57), and one understands that it won't be long before the smoky twilight fades into deep darkness. These photographs have numerous counterparts in the history of art, from British painting of the Romantic era by Thomas Girtin and J. M. W. Turner, who sought to depict the transitory effects of light and atmosphere, to Mark Rothko's melancholy abstractions, veils of shadowy umbers and blacks built from thin washes of pigment.

Occasionally Faust's pictures allude to another tradition in painterly representations of night: the dramatic. The genre was especially common before the invention of artificial light, when God-fearing citizens who ventured out in the dark encountered a host of dangers, both mortal and spiritual. Painted night scenes of this type usually contain fiery lighting effects (flames, candles, torches, moonlight) and depict such terrors as midnight conflagrations, imaginary infernos teeming with hellish creatures, and attacks by club-wielding thieves on moonless nights. Usually these pictures contain a single source of light, which draws the eye to the action while plunging the rest of the picture in darkness and provoking on the part of the viewer a vague anxiety associated with the unknown.

Psychological drama also animates art of the twentieth century, including film noir and surrealism; in photography one thinks of Brassaï's book *Paris by Night* and Weegee's lurid crime-scene pictures. Faust's rare nods to this genre, such as the technical tour de force *Cut Elevator Bin, GTA Demolition, St. Paul, Minnesota* (1989; Plate 29), keep drama at arm's length by pushing the action into the background and leaving the viewer safely ensconced in foreground shadows. The noirish *Parked Truck, Ortonville Co-op, Ortonville, Minnesota* (1996; Plate 1) is only slightly foreboding; had Faust skewed the perspective, it would be as ominous as a Chirico.

These pictures are effective partly because of their extraordinary fullness of tone. Faust achieves this richness through his prowess as a printer and his mastery of the Zone System, a classic darkroom methodology perfected in the early 1940s by Ansel Adams. Faust employs a modified version of the system, which makes possible the wide range of grays in his images. This loyalty to chemical analog processes (he uses no digital or electronic technology) is increasingly anachronistic, but it makes it possible for him to re-create the nighttime world much as we experience it: a delicate concoction of a thousand grays, blacks, and white. Still, taking photographs at night is a technical challenge, and in Faust's continued engagement with the project one is reminded of his adolescent efforts to achieve a moon bounce with radio waves: both are quests to record information that sits at the outer limits of human perception.

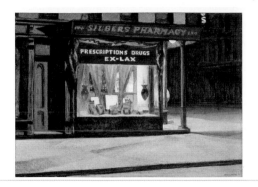

Edward Hopper, *Drug Store*, 1927. Museum of Fine Arts, Boston. Bequest of John T. Spaulding. Photograph copyright 2007 Museum of Fine Arts, Boston.

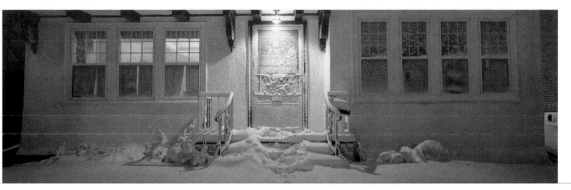

Chris Faust, *After a March Storm, St. Paul, Minnesota*, 1988.

"Not Too Clean"

Broadly speaking, Faust works in a venerable documentary tradition embodied by photographers such as Eugène Atget and Berenice Abbott. Both left hundreds of images that constitute vivid records of their cities: Atget cataloged Parisian street life during the first three decades of the twentieth century, and Abbott photographed New York City during the 1930s. Images by both artists brim with the particulars of life in a specific time and place, and by their very nature as records of a moment, their accuracy as documents is short-lived. Faust's nighttime tableaux may be more subdued than those of Atget and Abbott, but the data they record are no less ephemeral. The farms, towns, and cities of the upper Midwest, and the commercial arteries that connect them, are rapidly changing as a result of the decline of manufacturing and the rise of corporate agribusiness.

Faust often photographs establishments or industries that are on the edge of oblivion or have already slid into decay; in fact, he says he prefers subjects that aren't "too clean." *Machine Shop, CP Yard, Thunder Bay, Ontario* (1994; Plate 33) depicts a down-and-out trio of industrial buildings squatting on the outskirts of town. In the dark, they seem almost entirely drained of life; a light shines weakly from one window like a faint heartbeat. The train yard in *Union Pacific Yard and Office, Portland, Oregon* (1996; Plate 32) has a more vigorous look, but the real energy in this picture is in the background, where the city sparkles. In comparison, the railroad complex looks heavy and

dull, and everything about it—from its old-fashioned logo to its brick smokestack—evokes an outmoded past. *DM&IR Docks, Agate Bay, Two Harbors, Minnesota* (1994; Plate 56) owes something to the heroic industrial images of Margaret Bourke-White, Charles Sheeler, and even the Russian Constructivists, but unlike them Faust is not celebrating Modernity. Rather, this picture reminds us that the once-mighty mining concerns of northern Minnesota, which operated railroads and shipping lines on the Great Lakes during the early twentieth century, are part of a faded and debased industry that we now know stripped the land and polluted the water. Sites like these have the visual and narrative texture that Faust looks for; he isn't attracted to the new or the slick.

This doesn't mean he's a sentimentalist. *Bait Shop, French Island, La Crosse, Wisconsin* (1996; Plate 65) is a delightful reminder of the way leisure time has transformed the upper Mississippi River, and *M & C Gas Station, Superior, Wisconsin* (1992; Plate 15) depicts a tidy service station with a gabled roof that looks friendly and domestic. A five-pointed neon star—a common motif on lighted signs—beckons us home.

Faust's images of houses, alleyways, interiors, shops, and other domestic scenes owe a debt to the artist Edward Hopper, a photographically inclined painter whose affectionate observations of the world around him were concerned above all with light. He painted morning sun streaming through bare windows, the glare of noon on whitewashed walls, the warm glow and long shadows of late afternoon. Among his many night scenes is an image of a corner pharmacy whose

shopwindow glows invitingly, framed by inky shadows and a deserted sidewalk. Faust has also documented commercial establishments at night, but while Hopper's have a melancholy air, Faust's are droll. He favors the small-scale, unique, and quirky; typical are *Wig-O-Rama, Tucson, Arizona* (1992; Plate 61), with its absurd display of bewigged mannequin heads behind bars, and *Inside Schmidty's Sports Barbers, St. Paul, Minnesota* (1995; Plate 64), where customers can get an eleven-dollar haircut while watching the Big Game on TV.

One of the first nighttime images Faust made records the façade of a St. Paul house after a spring snowfall. The windows are stippled with frost, the porch light is on, and someone's footsteps have made depressions on the snowy steps. This is a familiar sight to anyone who has ever rushed off to work on a dark winter morning, leaving the shoveling until later, but the image also provokes a tug of longing for the comforts of home. Outside it's cold and dark, while inside there is warmth, light, protection from the weather, maybe even family, dinner, and love. Perhaps we could go in—there is an implicit invitation in those footprints leading to the porch, where someone has left a light on. Yet something about the image suggests that we should stay where we are. It might be the stasis of Faust's symmetrical composition, or the simple visual "no" of the closed storm door, coated with undisturbed snow. And this is the wonder of Faust's night pictures: to view them is to enter a world without menace, a world that is tranquil and even inviting. So we linger outside, in the dark, with pleasure.

Notes

1. Statement on Faust's Web site, www.chrisfaustphoto.com, January 17, 2006.
2. Frank Edgerton Martin, "Making Pictures: Photographer Chris Faust Encourages New Questions," *Landscape Architecture* 91, no. 10 (October 2001): 89.
3. *Mike Lynch: 2003 Distinguished Artist* (Minneapolis: McKnight Foundation, 2003), 28.

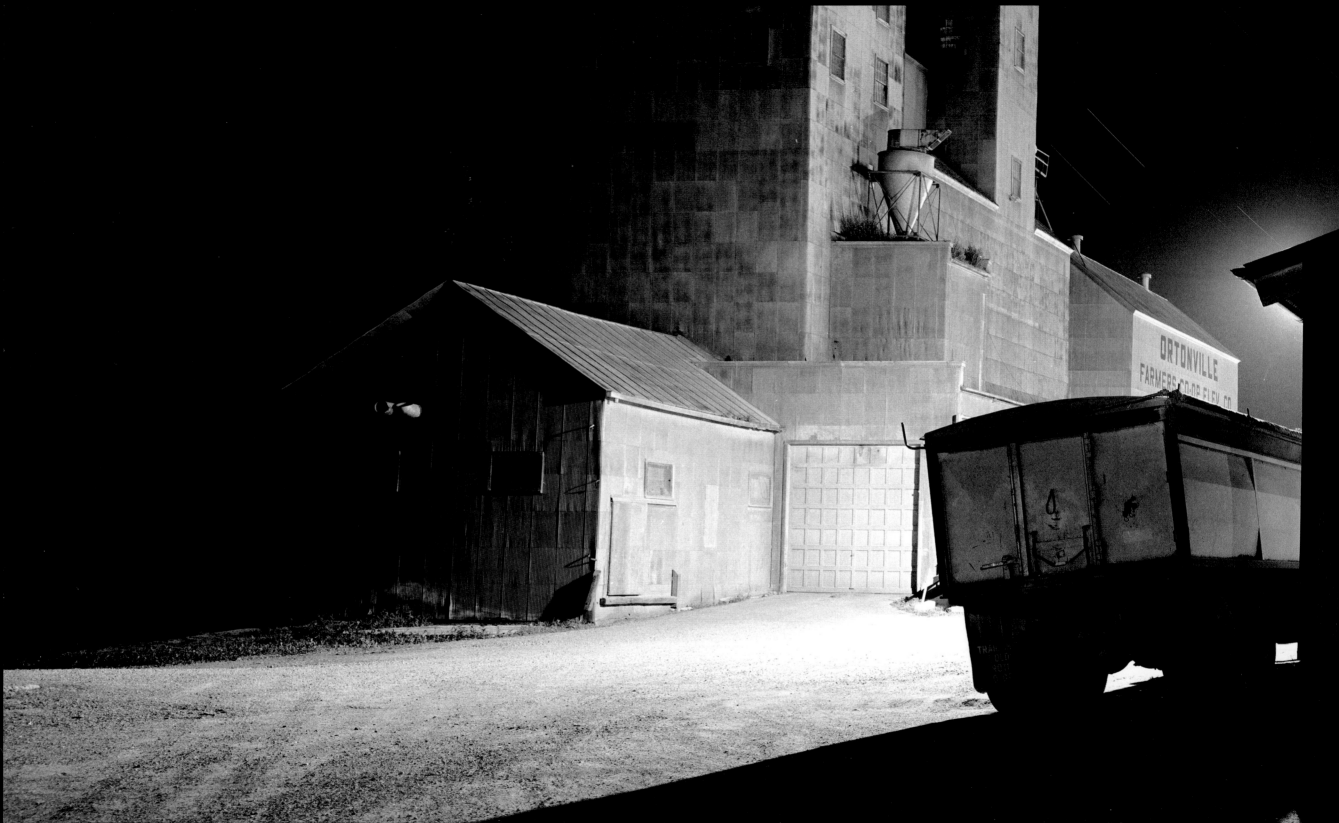

Nocturnes

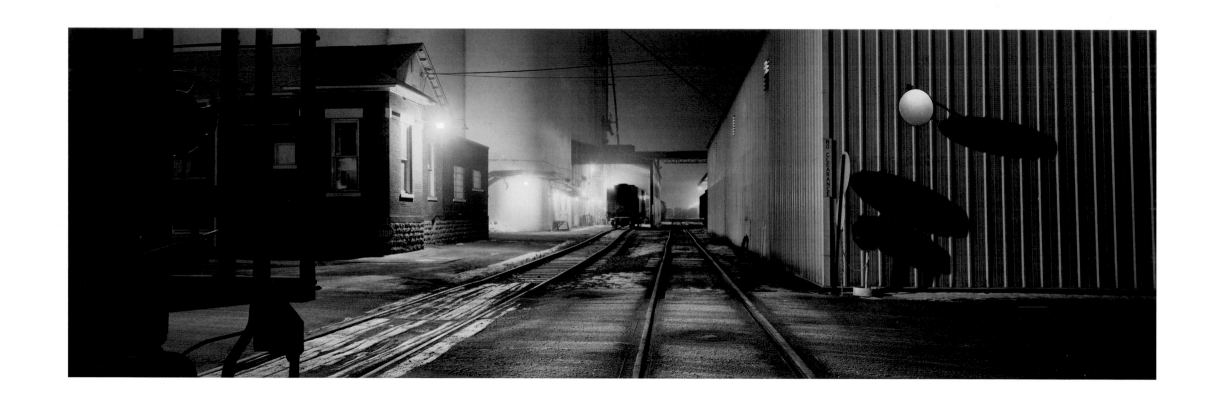

Plate 2. Bay City Milling, Winona, Minnesota, 1994

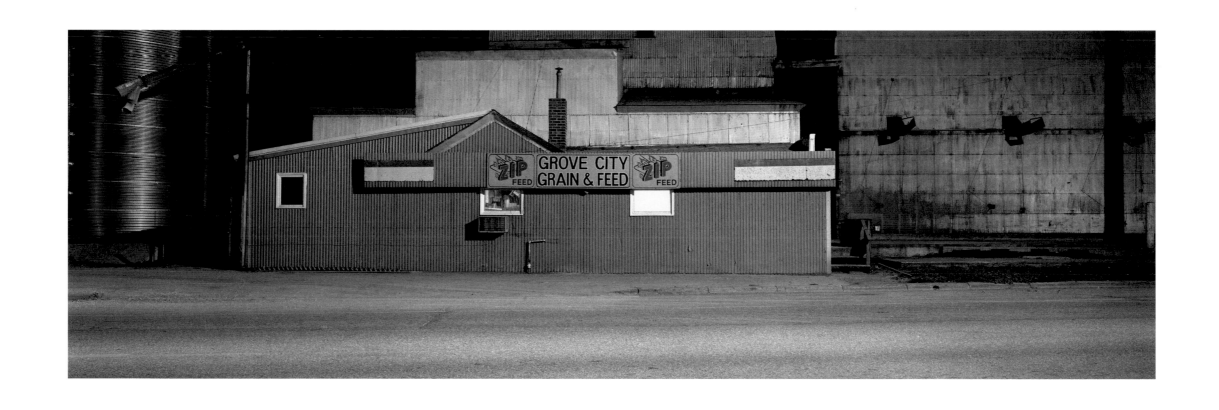

Plate 3. Grove City Co-op, Grove City, Minnesota, 1994

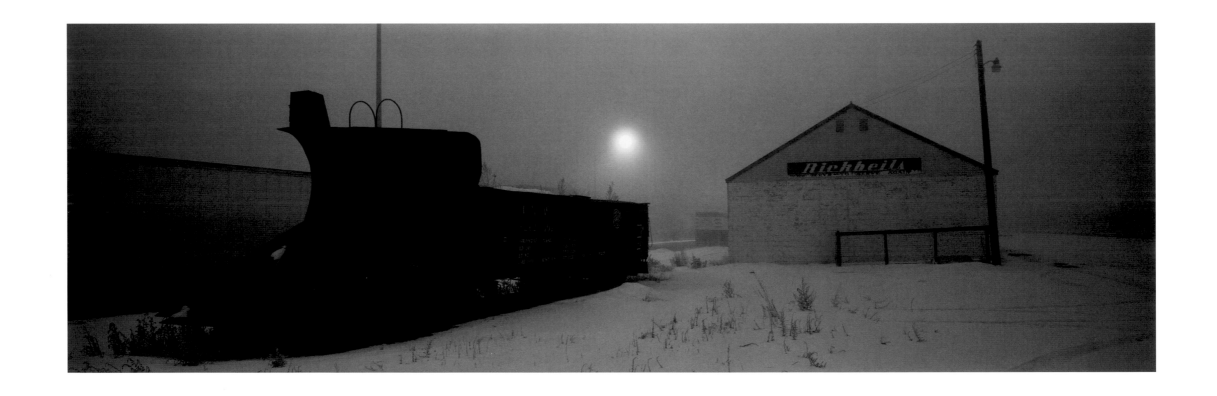

Plate 4. C&NW Snowplow, Worthington, Minnesota, 1994

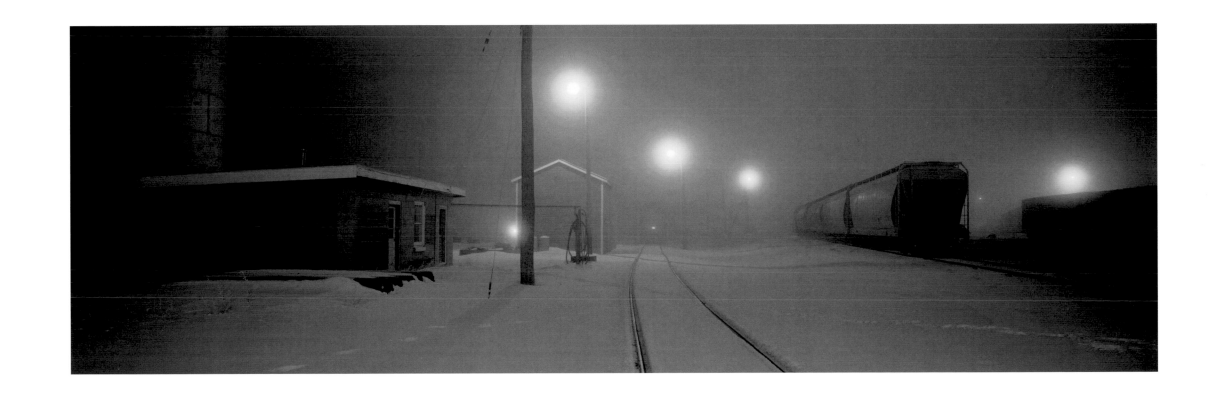

Plate 5. C&NW Switchyard, Worthington, Minnesota, 1994

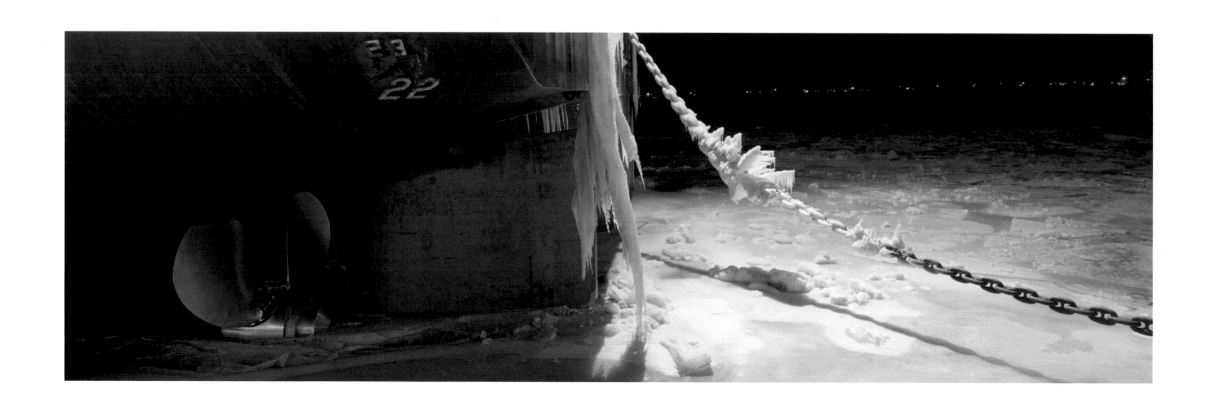

Plate 6. Prop of the *Walter J. McCarthy Jr.*, Duluth, Minnesota, 1990

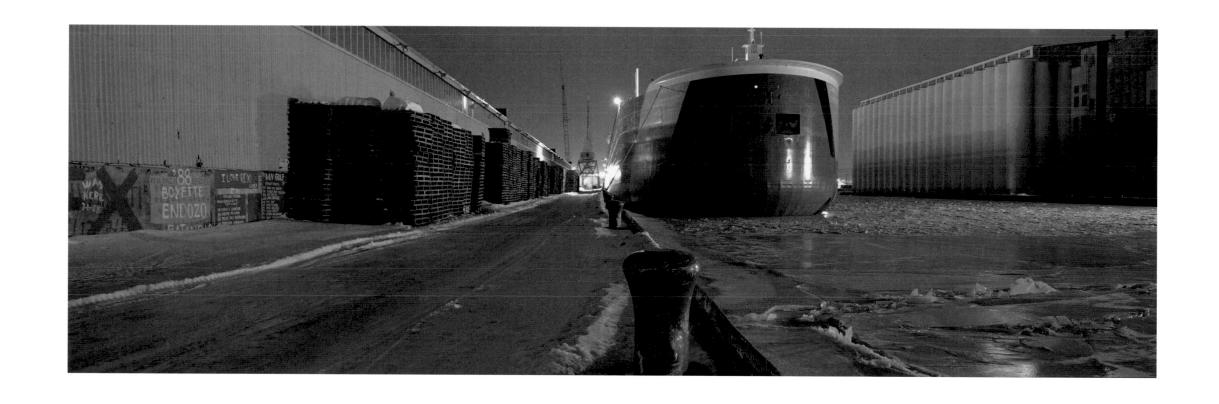

Plate 7. *Edwin Gott*, Duluth, Minnesota, 1992

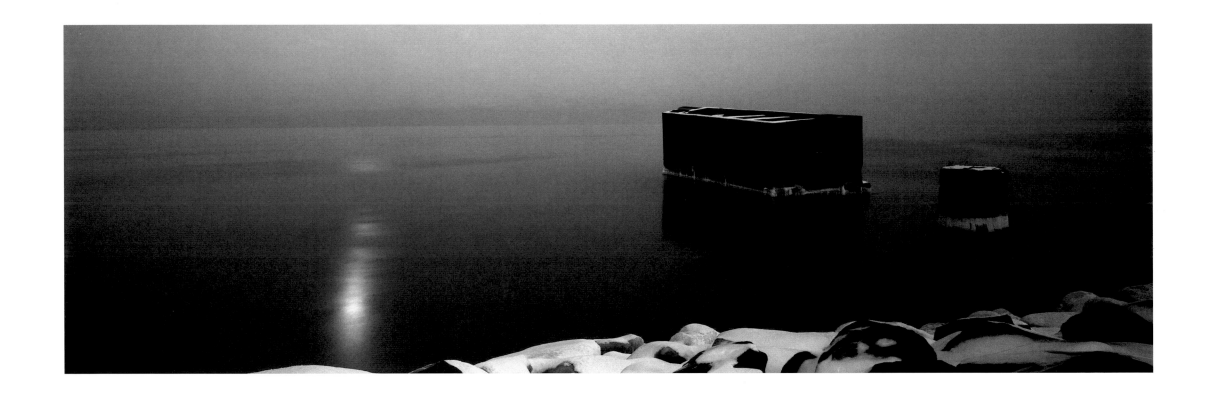

Plate 8. Moonrise over Canal Park, Duluth, Minnesota, 1990

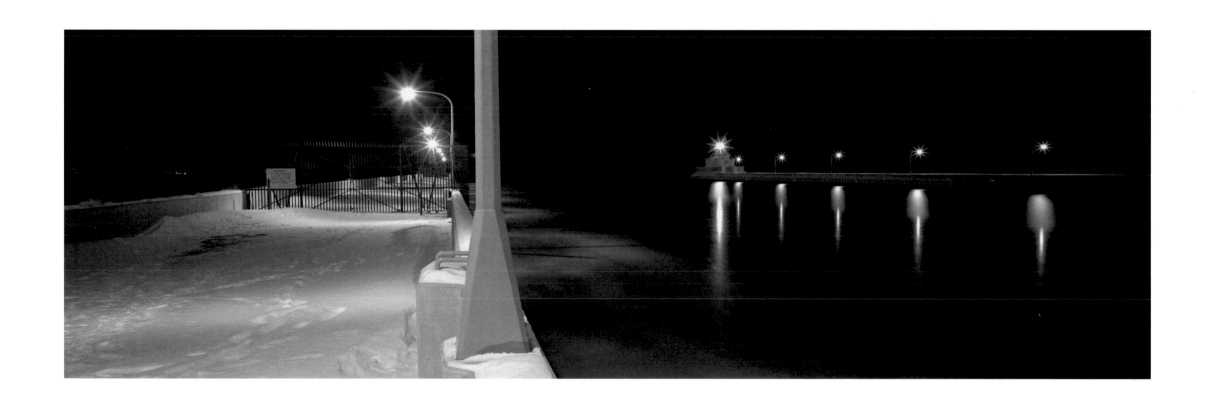

Plate 9. Ice Going out to Lake Superior, Duluth, Minnesota, 1990

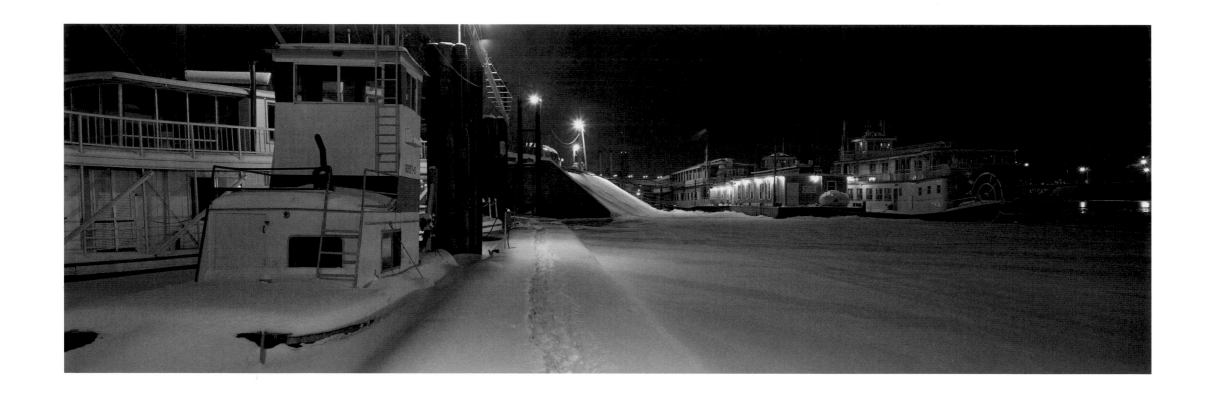

Plate 10. Boats Frozen in for the Winter, St. Paul, Minnesota, 1991

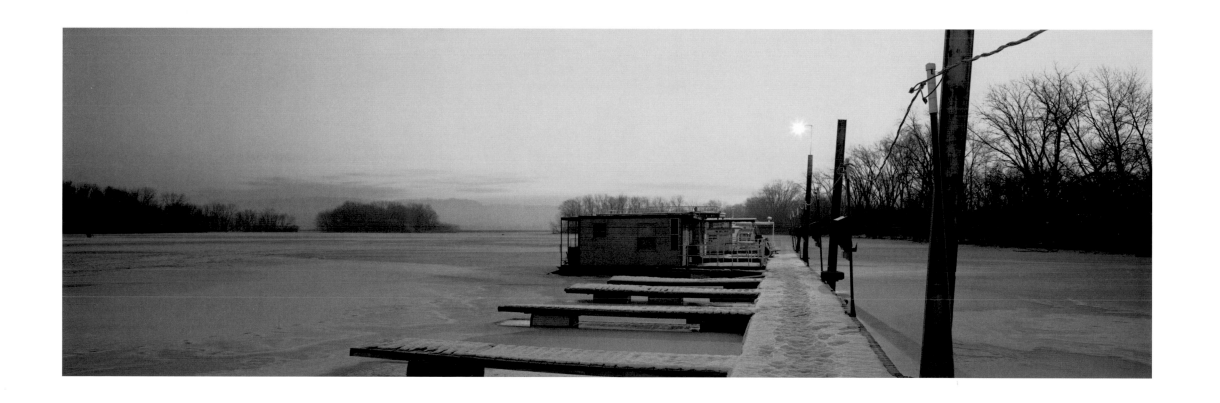

Plate 11. Houseboat Marina, near Minnesota City, Minnesota, 1994

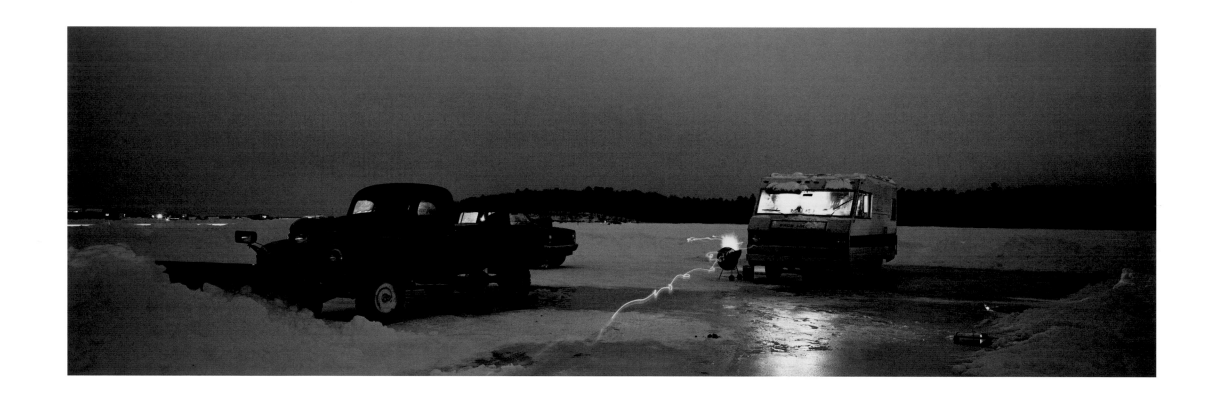

Plate 12. Grilling and Ice Fishing, Leech Lake, Minnesota, 1996

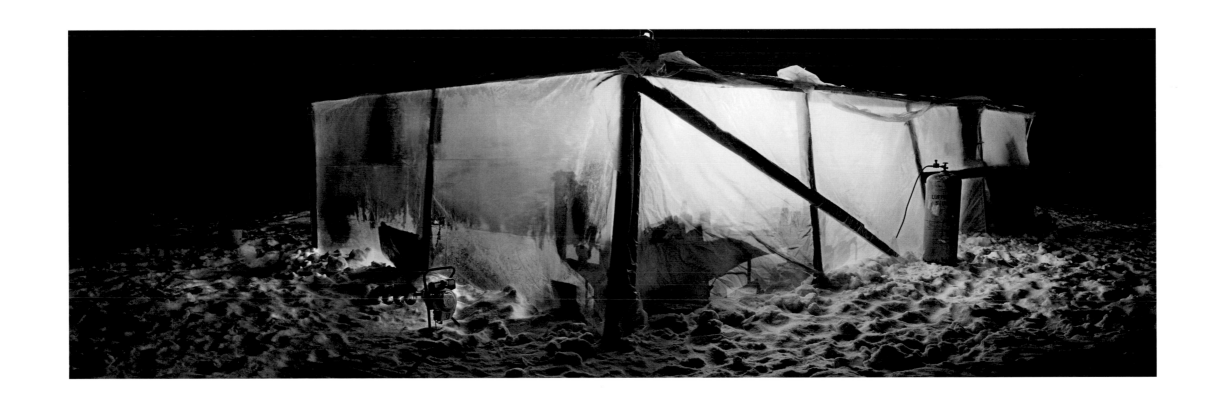

Plate 13. Poutological Research Center, Eelpout Festival, Leech Lake, Minnesota, 1996

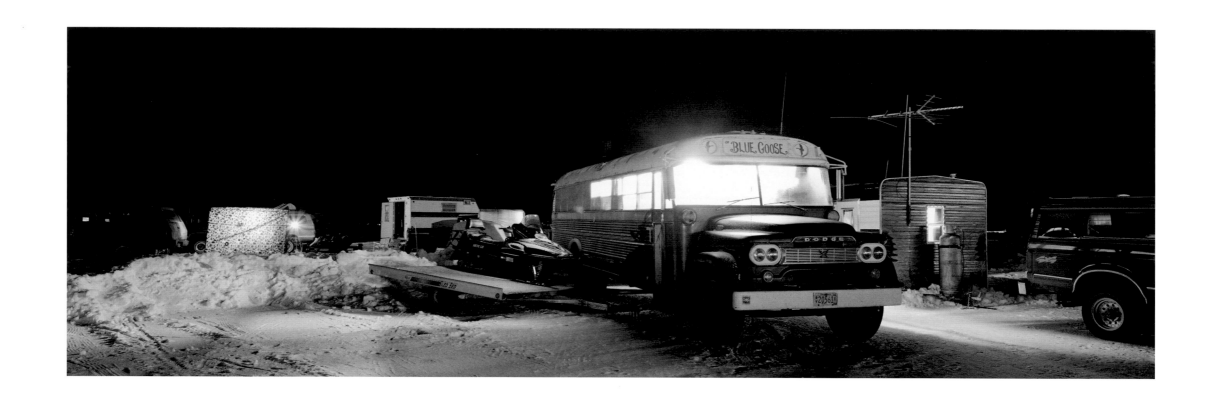

Plate 14. Blue Goose Fishing Camp, Eelpout Festival, Leech Lake, Minnesota, 1996

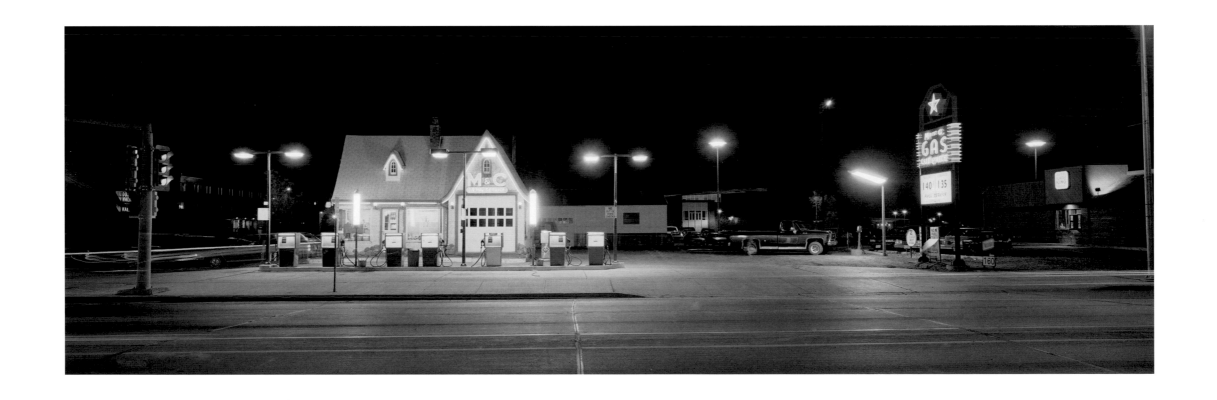

Plate 15. M & C Gas Station, Superior, Wisconsin, 1992

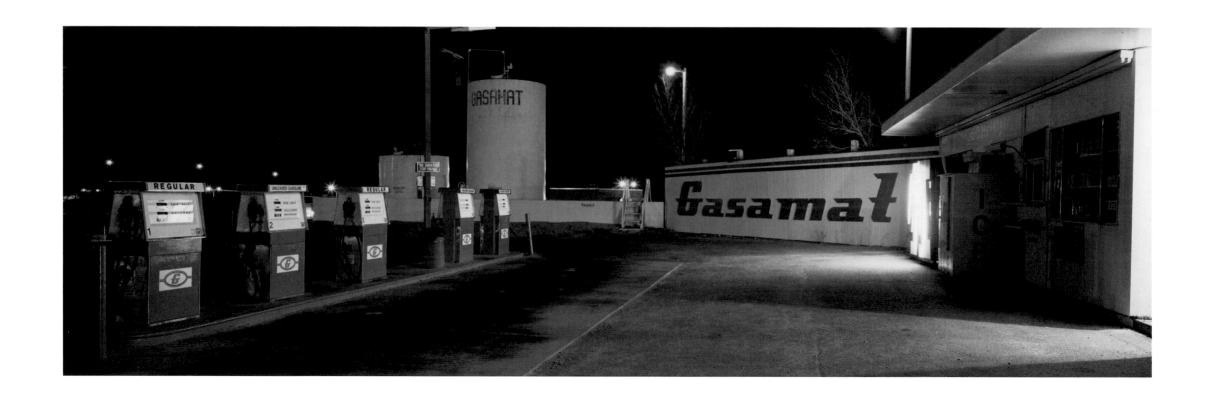

Plate 16. Gasamat, Lajunta, Colorado, 1992

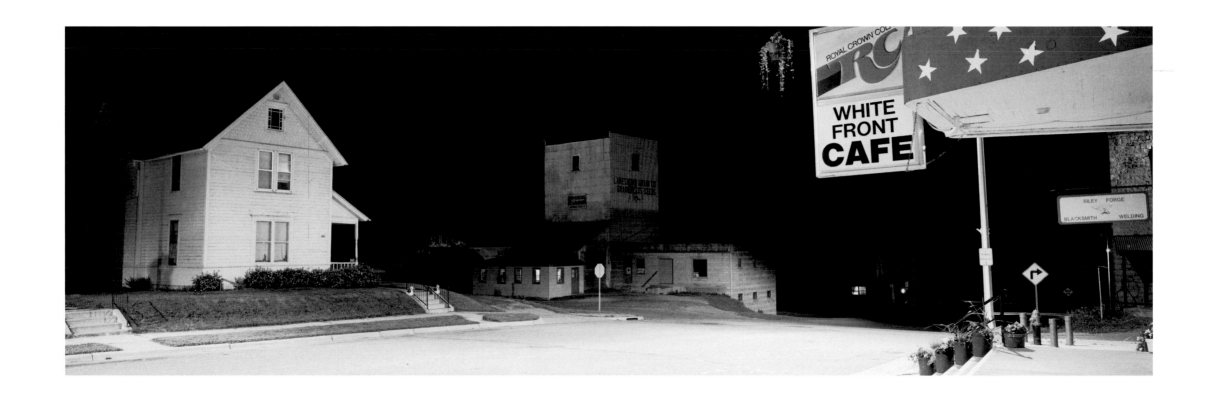

Plate 17. White Front Café, Lanesboro, Minnesota, 1989

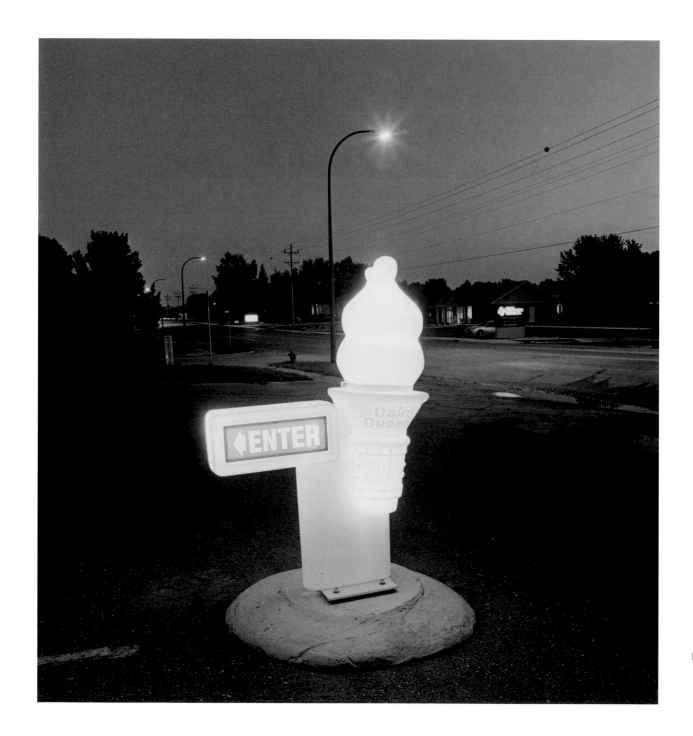

Plate 18. Dairy Queen Entrance Light, Watertown, South Dakota, 1997

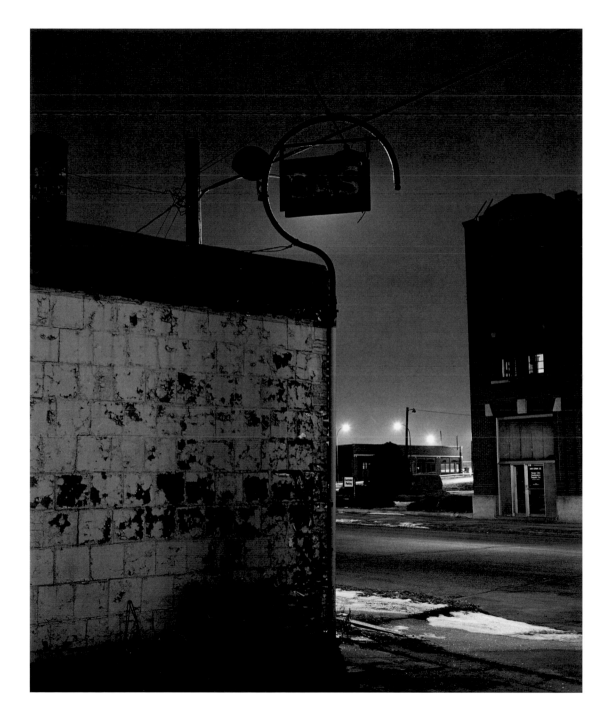

Plate 19. Old Gas Station, Sioux City, Iowa, 1995

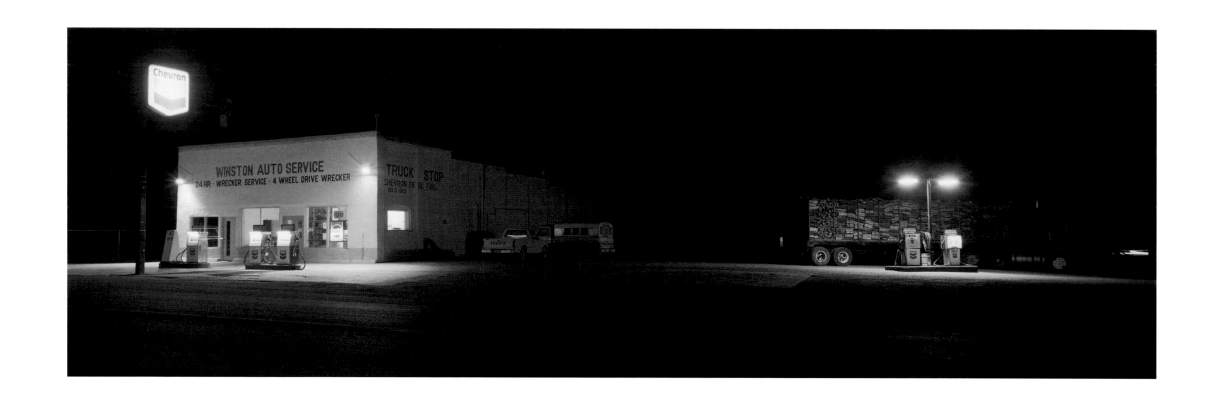

Plate 20. Gas Station, Magdalena, New Mexico, 1992

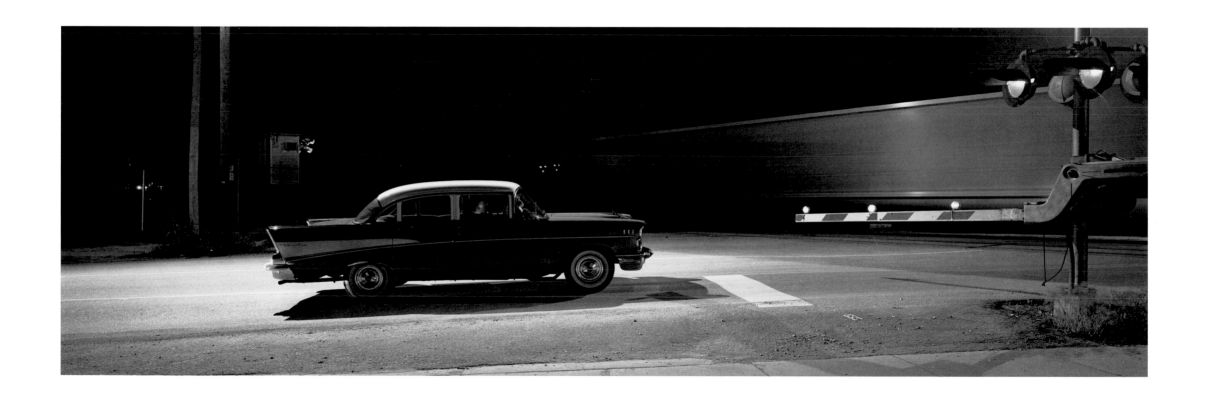

Plate 21. Waiting at the Crossing, Lincoln, Nebraska, 1993

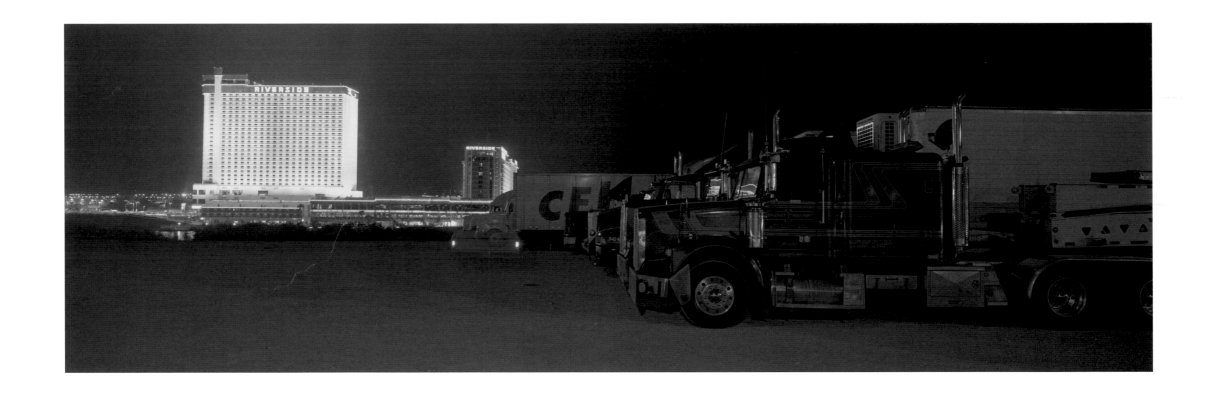

Plate 22. Truck Stop, with View of Casino, Bullhead City, Arizona, 1997

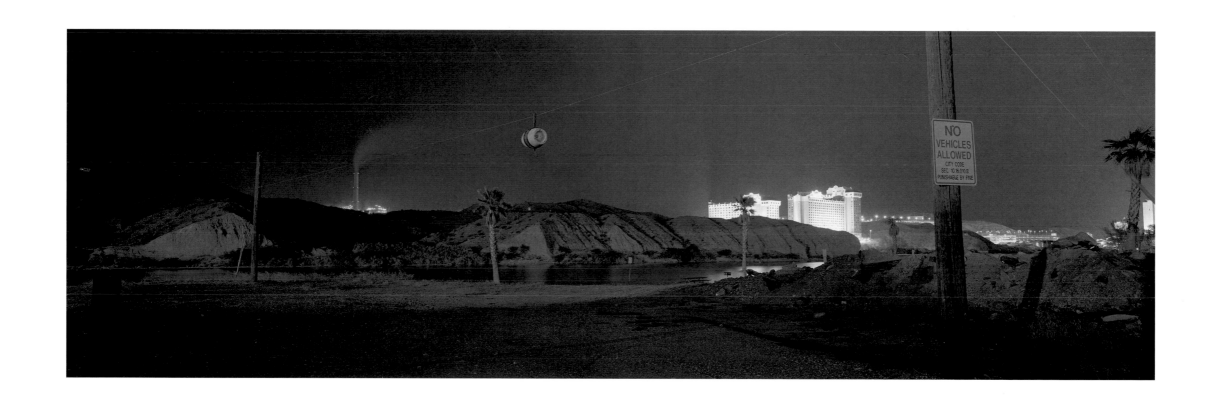

Plate 23. City Park, with Water Cannon Target and View of Casino, Bullhead City, Arizona, 1997

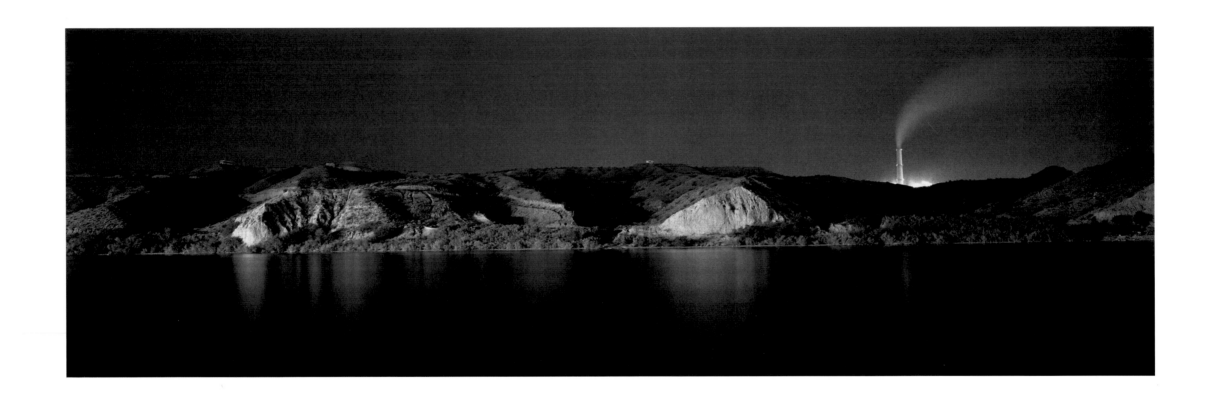

Plate 24. View of Power Plant in Laughlin, Nevada, 1997

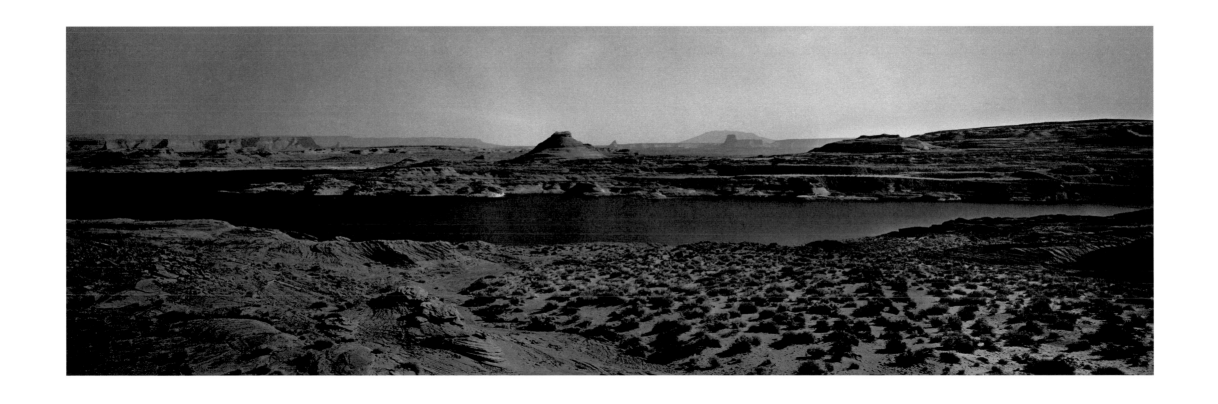

Plate 25. Lake Powell at Midnight and Full Moon, near Page, Arizona, 1996

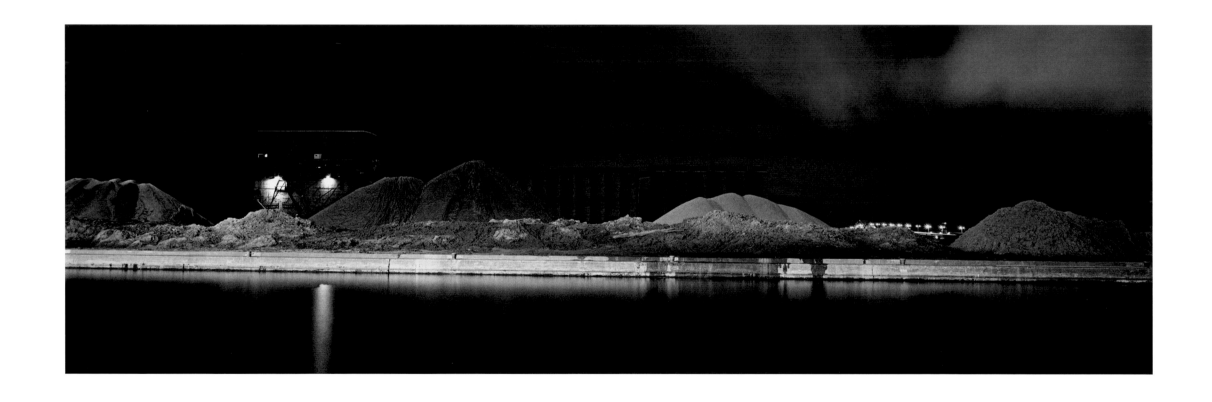

Plate 26. Old Peavey Slip, Duluth, Minnesota, 1997

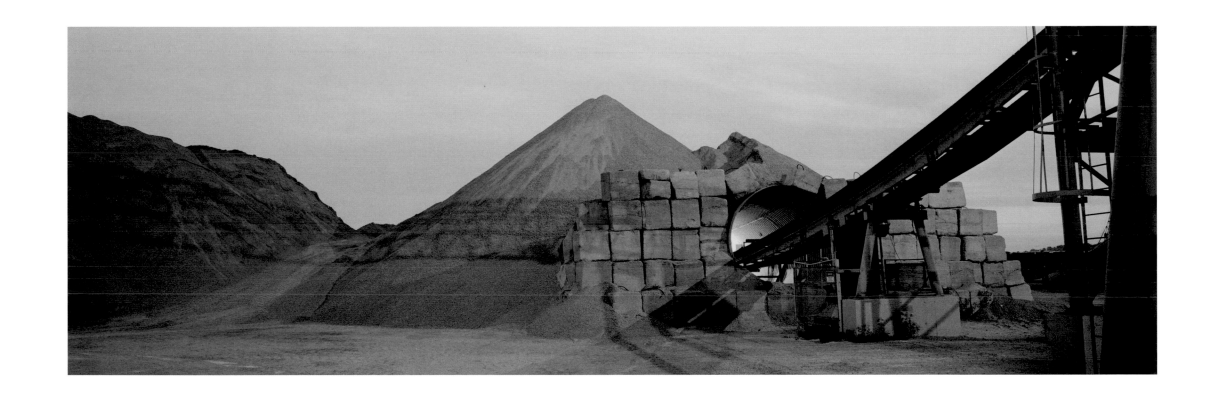

Plate 27. Gravel Conveyor, Shiely Yard "A," St. Paul, Minnesota, 1991

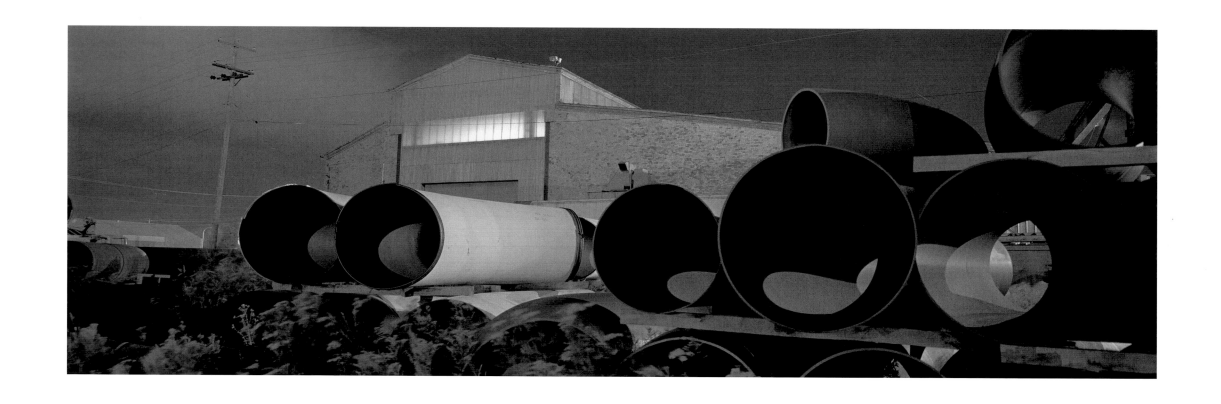

Plate 28. Bend-Tech Pipe Yard, Duluth, Minnesota, 1997

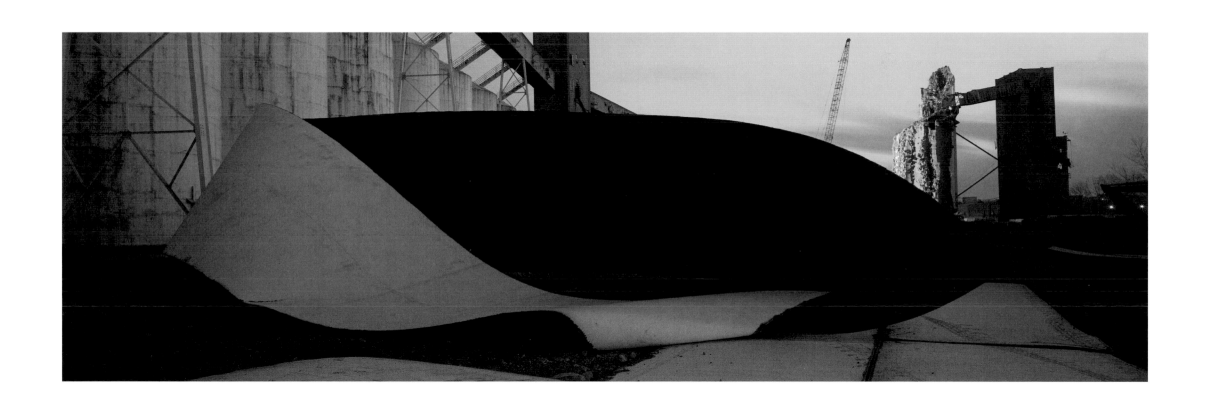

Plate 29. Cut Elevator Bin, GTA Demolition, St. Paul, Minnesota, 1989

Plate 30. Elevator Bin Detail and Conveyor Demolition, St. Paul, Minnesota, 1989

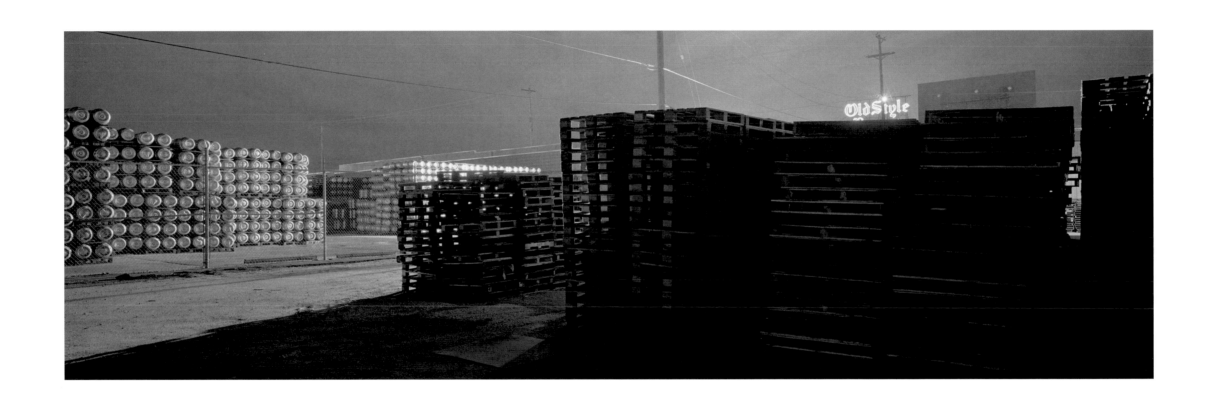

Plate 31. Pallet and Keg Yard, Old Style Brewery, La Crosse, Wisconsin, 1996

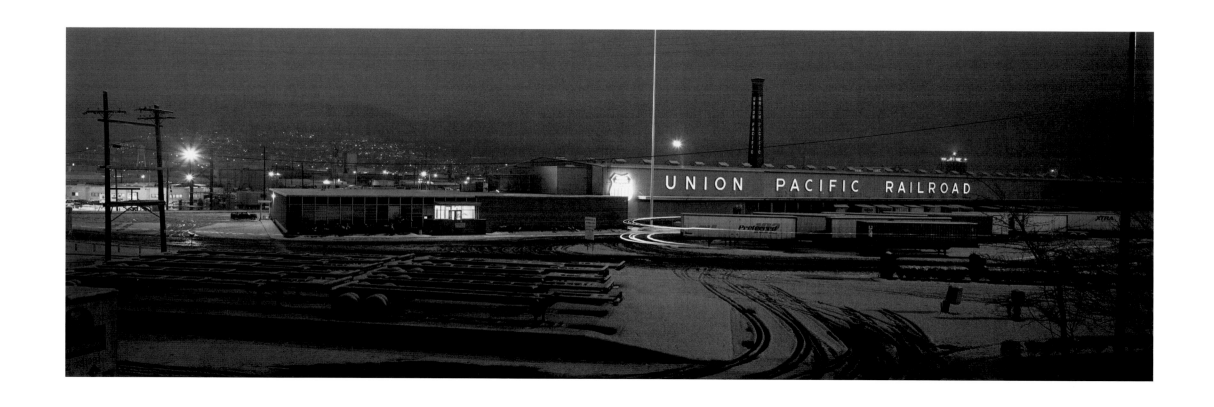

Plate 32. Union Pacific Yard and Office, Portland, Oregon, 1996

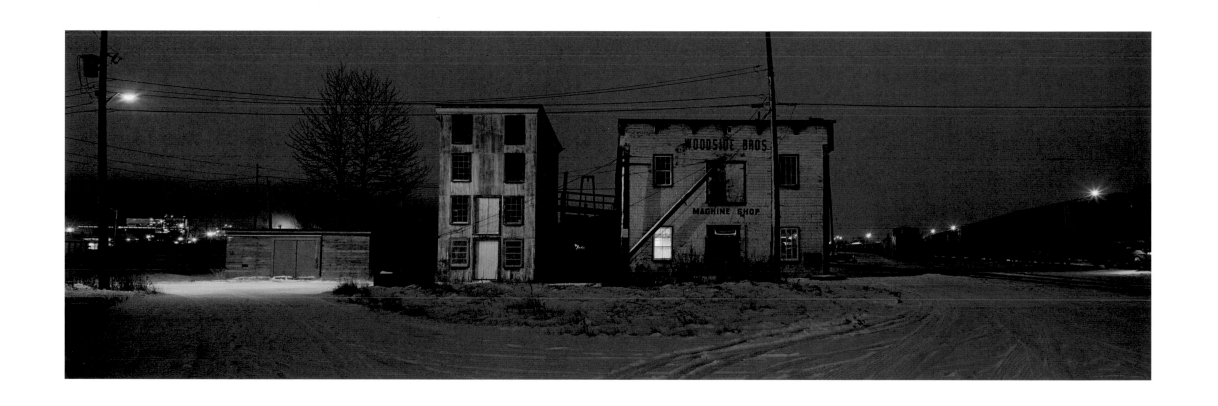

Plate 33. Machine Shop, CP Yard, Thunder Bay, Ontario, 1994

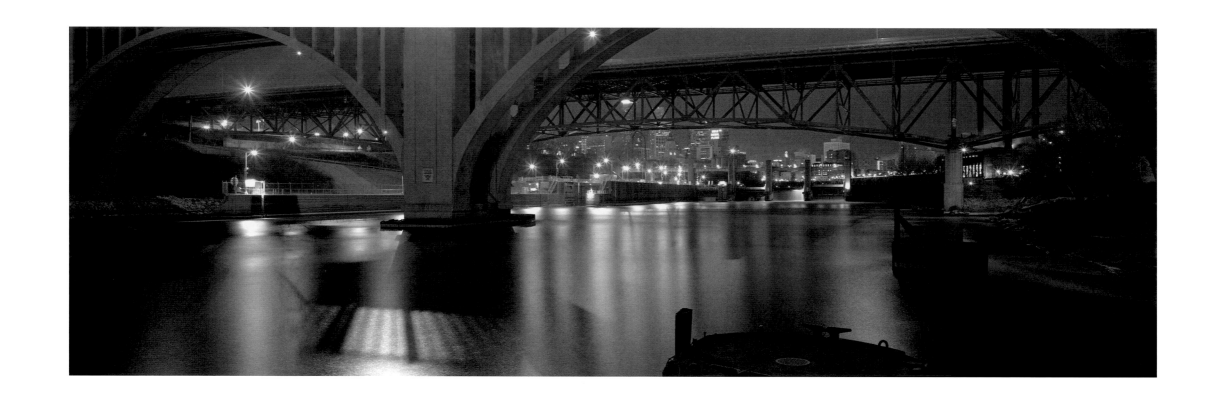

Plate 34. View of Downtown Minneapolis under Tenth Avenue Bridge, Minneapolis, Minnesota, 2002

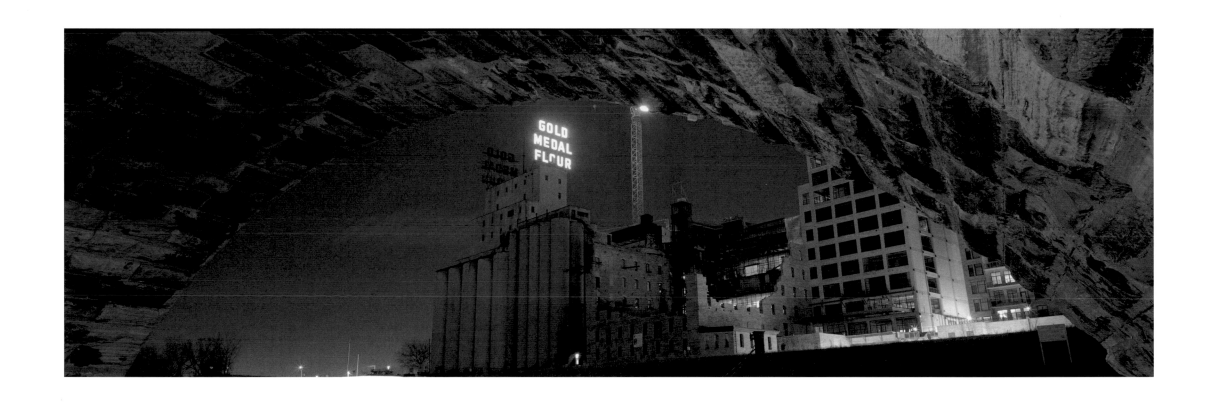

Plate 35. View of Gold Medal Flour Site from under Stone Arch Bridge, Minneapolis, Minnesota, 2002

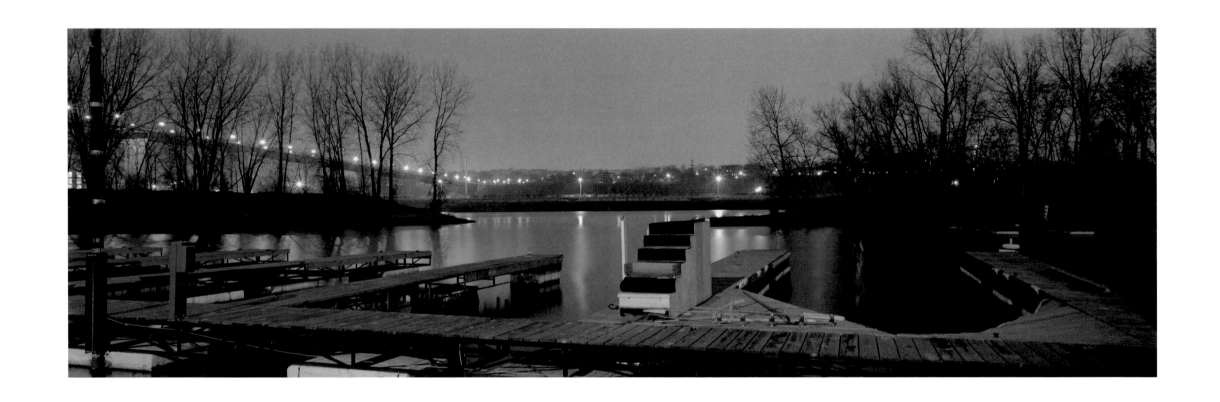

Plate 36. Empty Slips, St. Paul Yacht Club, St. Paul, Minnesota, 1993

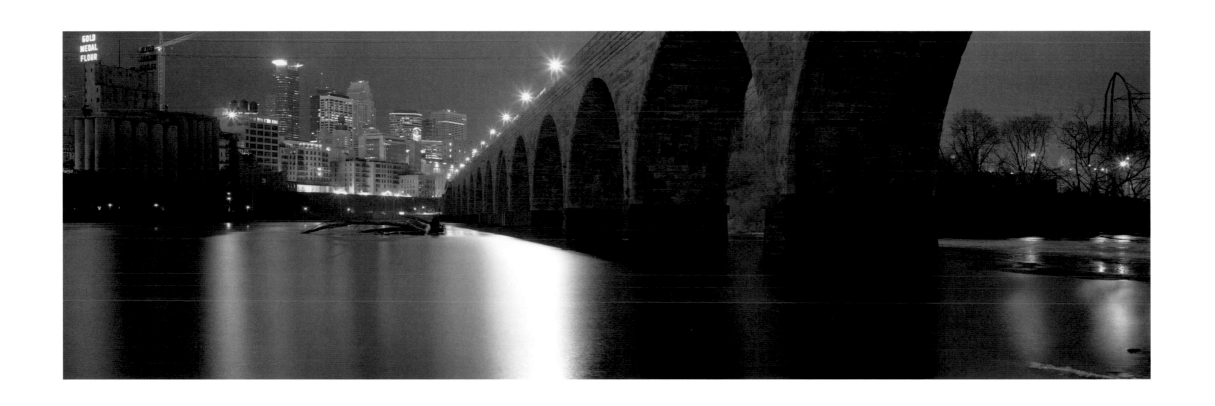

Plate 37. View of Downtown Minneapolis from Base of Stone Arch Bridge, Minneapolis, Minnesota, 2002

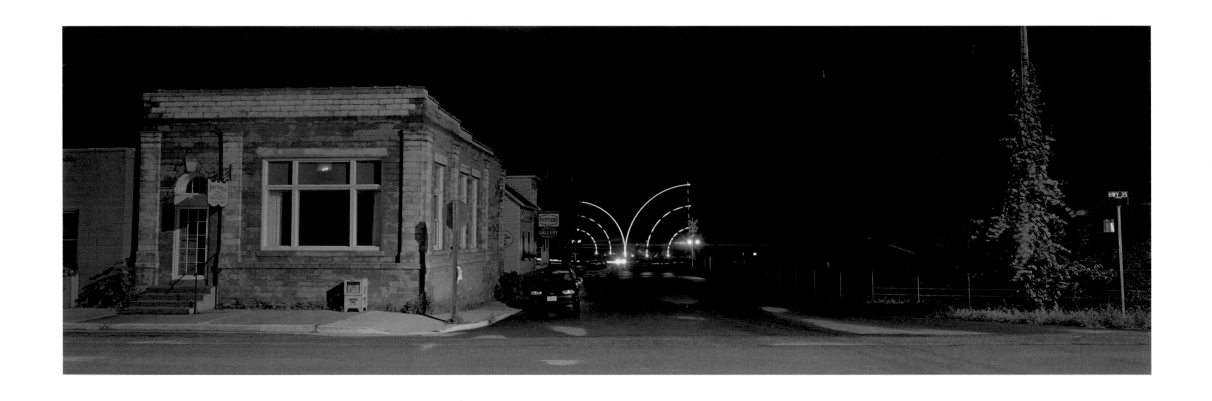

Plate 38. BNSF Railroad Crossing, Stockholm, Wisconsin, 1996

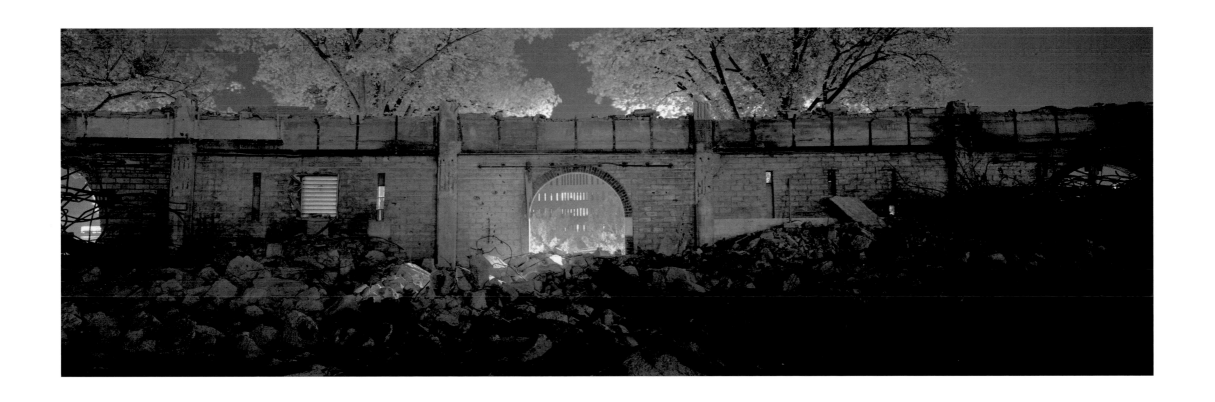

Plate 39. Memorial Stadium Demolition, University of Minnesota Campus, Minneapolis, Minnesota, 1993

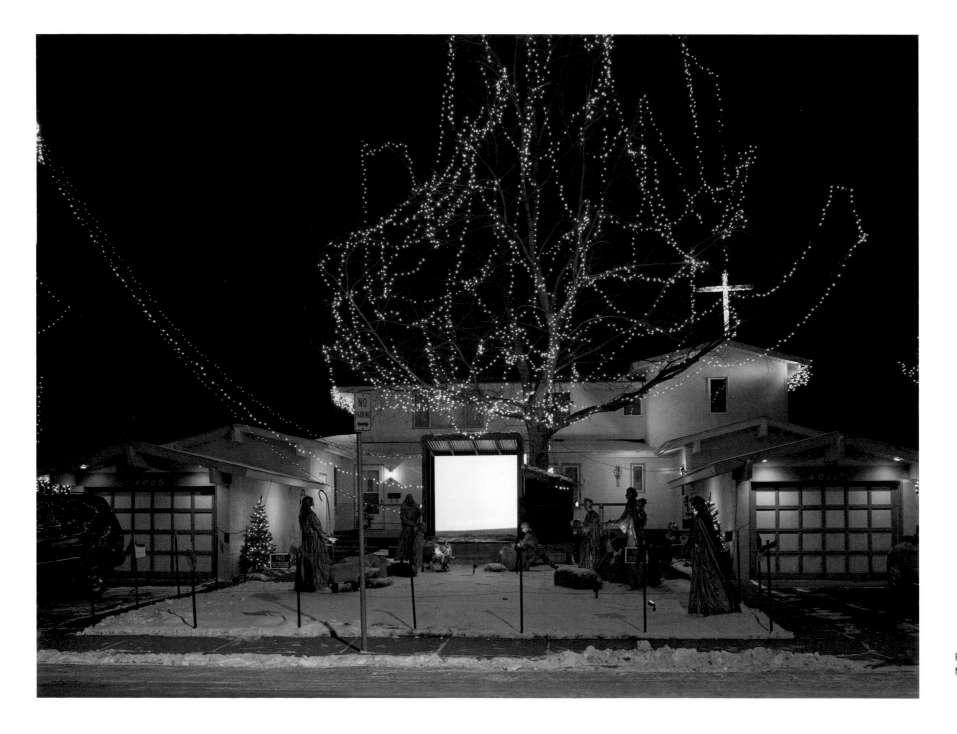

Plate 40. Christmas Light Display, Longfellow
Neighborhood, Minneapolis, Minnesota, 2001

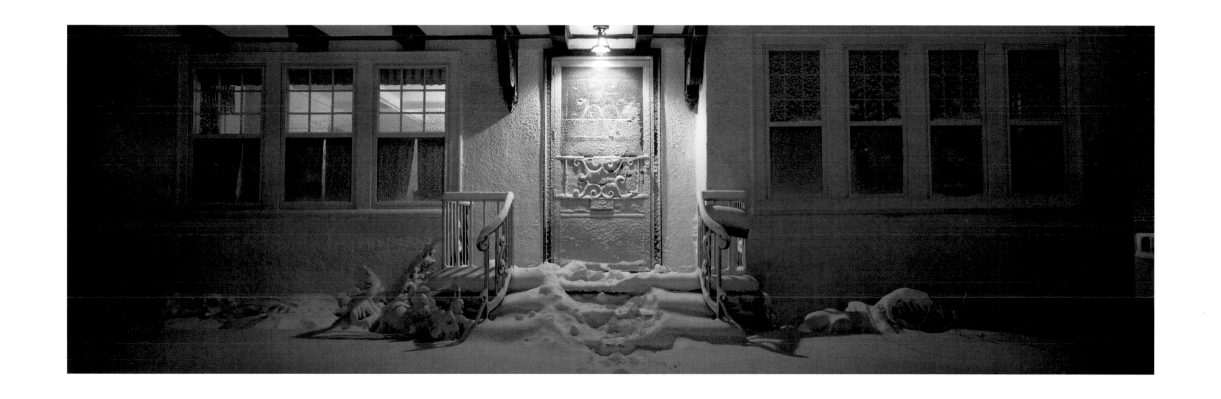

Plate 41. After a March Storm, St. Paul, Minnesota, 1988

Plate 42. Alley Detail between Garages, St. Paul, Minnesota, 2000

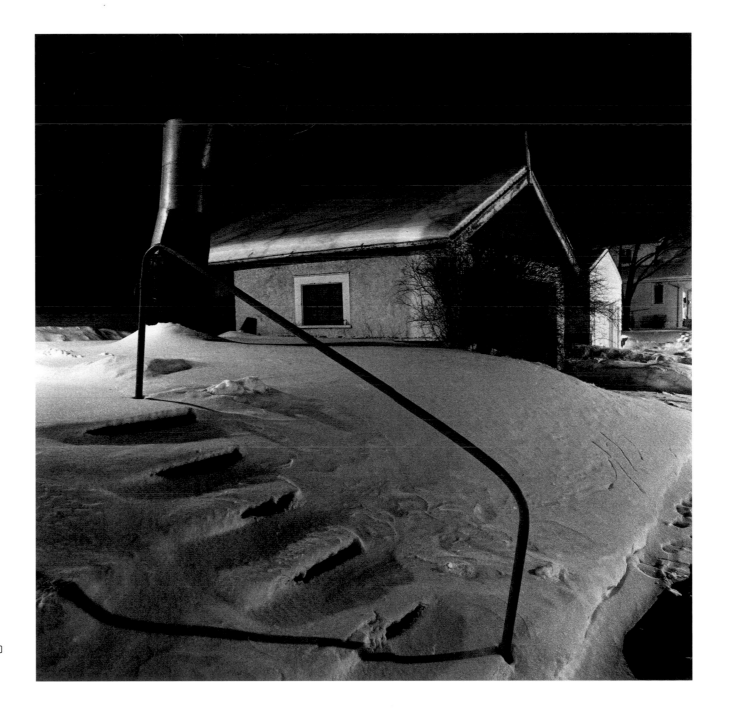

Plate 43. Garage Detail, Albert Avenue, St. Paul, Minnesota, 2000

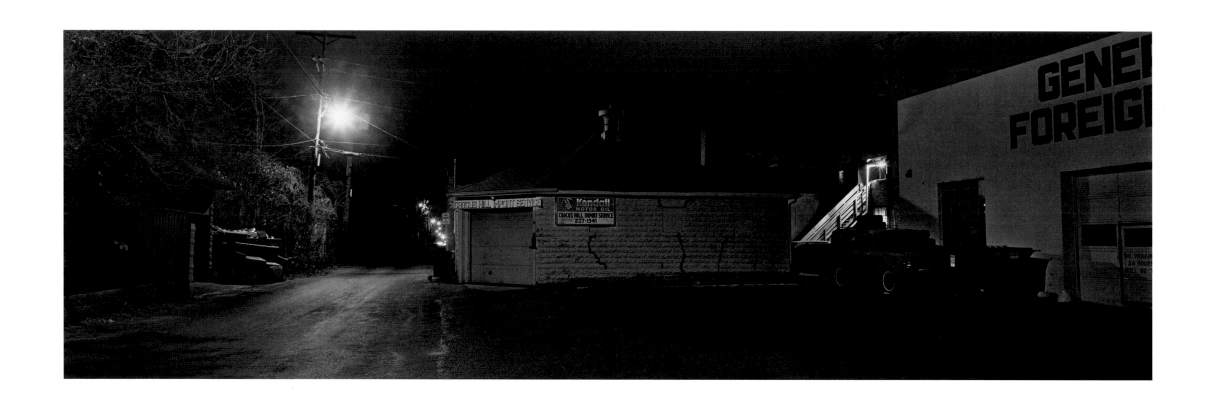

Plate 44. Garage and Alley Detail, Crocus Hill, St. Paul, Minnesota, 1992

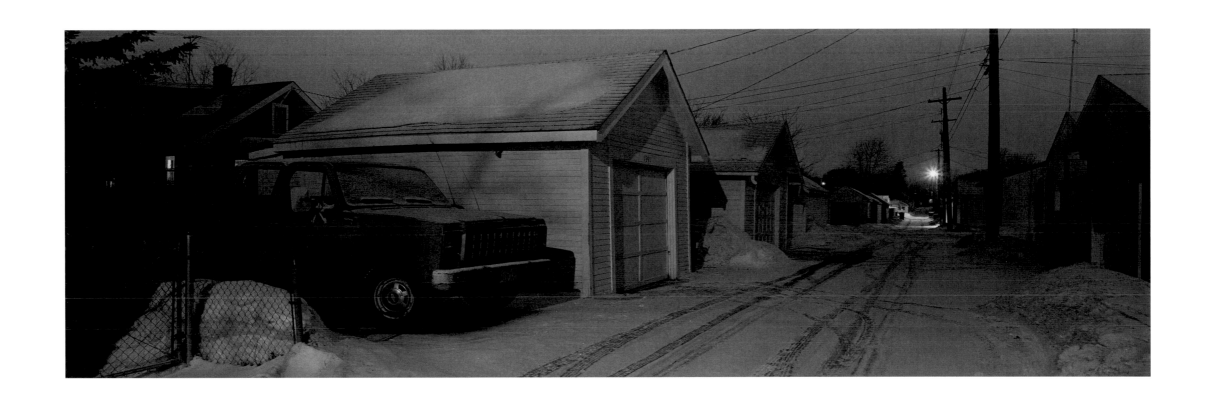

Plate 45. Alley Detail off Juliet Avenue, St. Paul, Minnesota, 1996

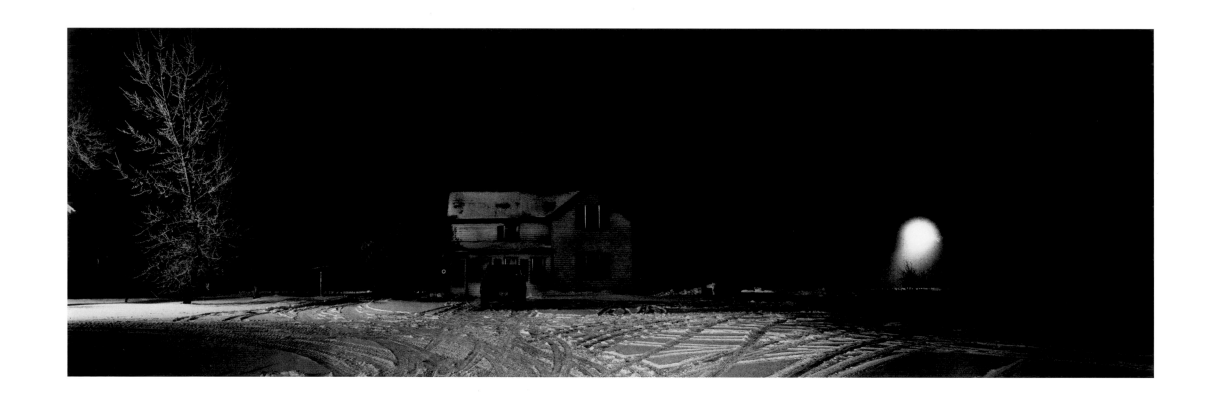

Plate 46. House on the Edge of Town, Worthington, Minnesota, 1994

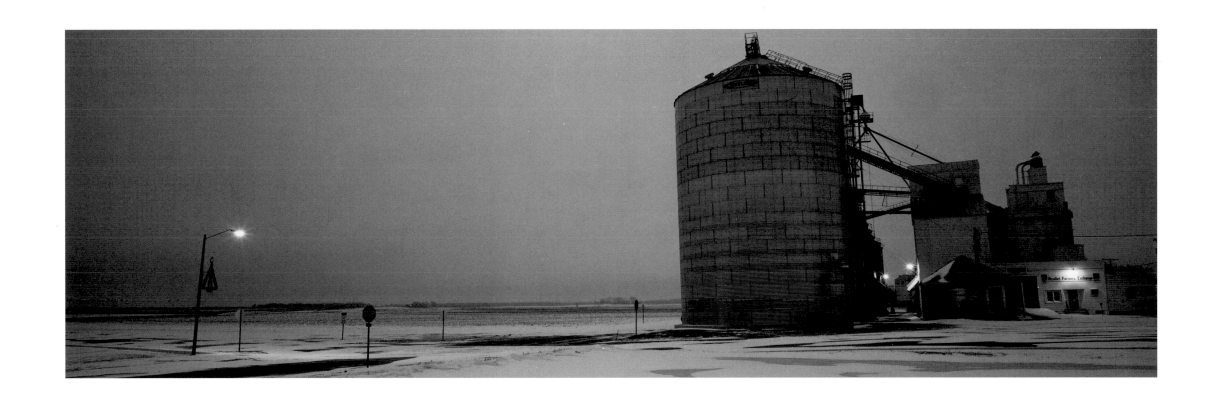

Plate 47. Christmas Morning, Nicollet, Minnesota, 1989

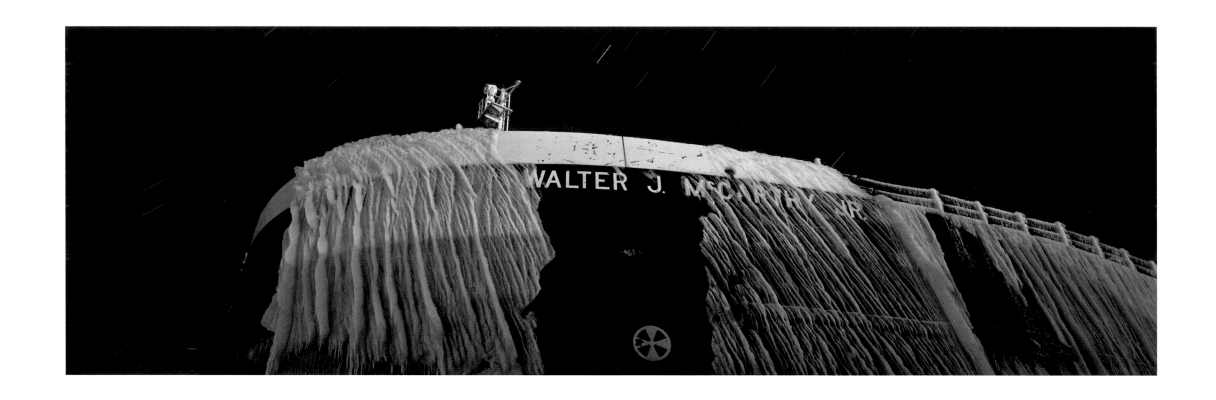

Plate 48. Bow of the *Walter J. McCarthy Jr.*, Duluth, Minnesota, 1990

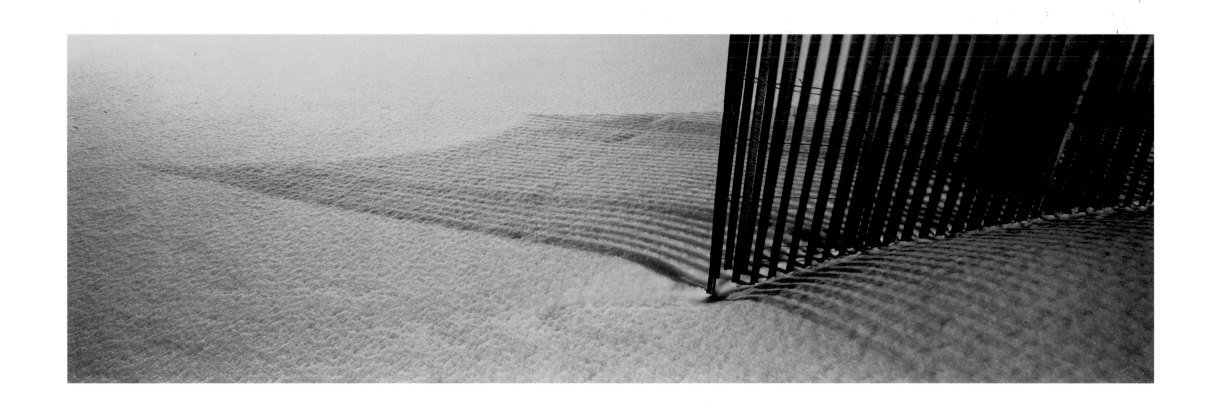

Plate 49. Snow Fence, Duluth, Minnesota, 1990

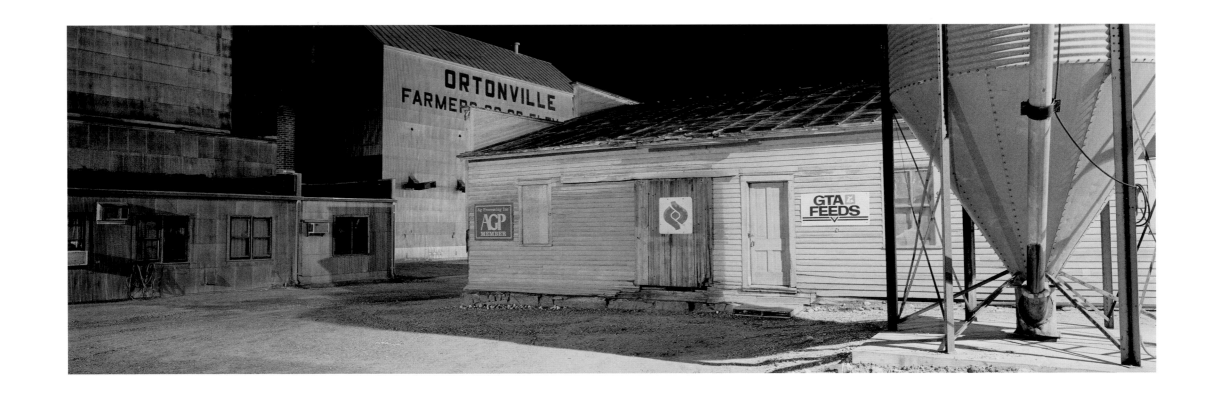

Plate 50. Ortonville Farmers Co-op, Ortonville, Minnesota, 1996

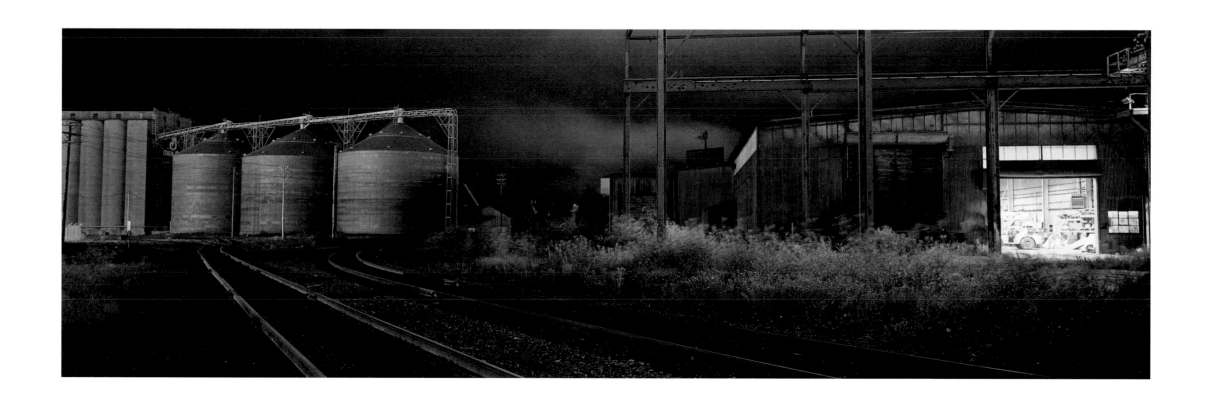

Plate 51. General Mills Elevator Detail and Bend-Tech Plant, Duluth, Minnesota, 1996

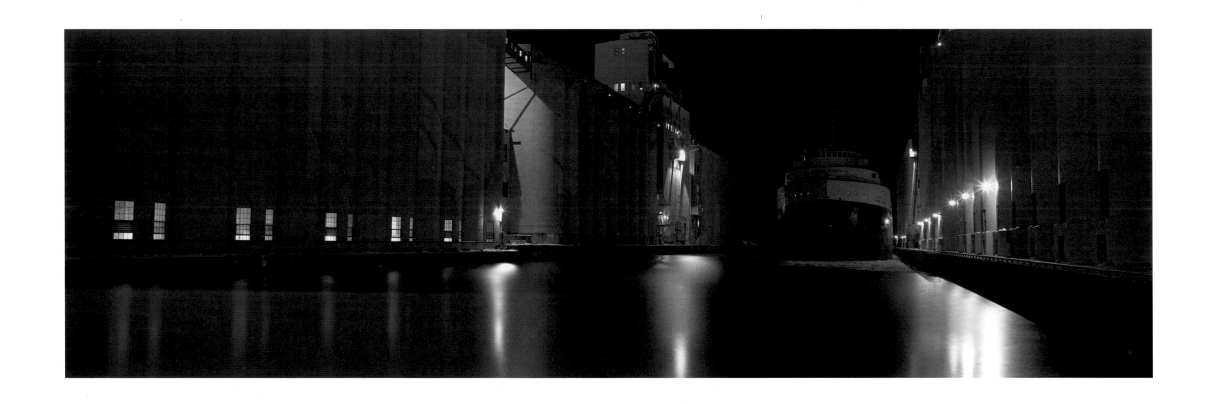

Plate 52. *Peter Misener*, Thunder Bay, Ontario, 1994

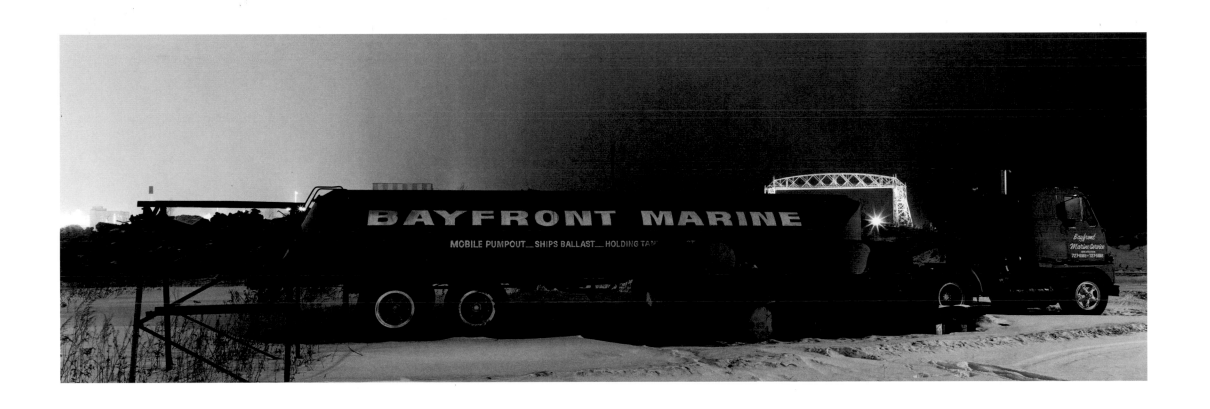

Plate 53. Bayfront Marine Tanker Truck, Duluth, Minnesota, 1990

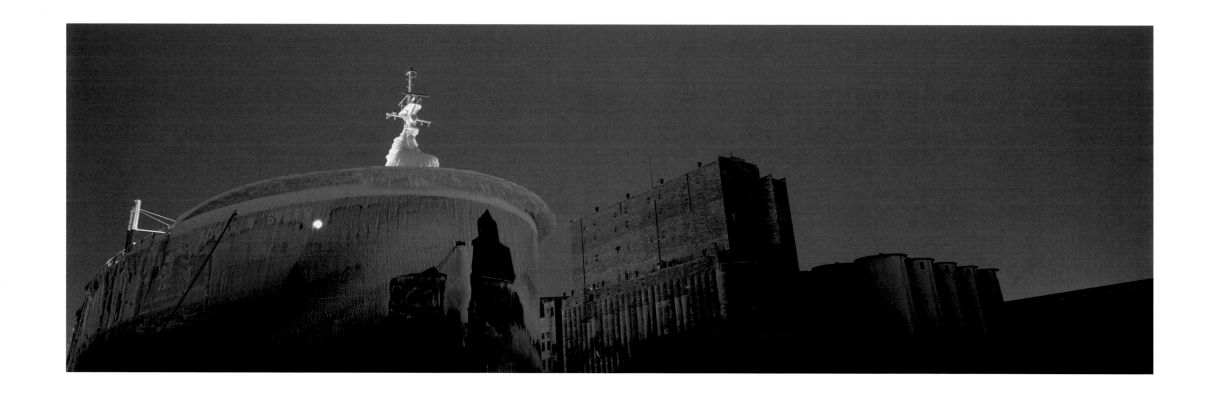

Plate 54. *Edgar B. Speer*, Duluth, Minnesota, 1990

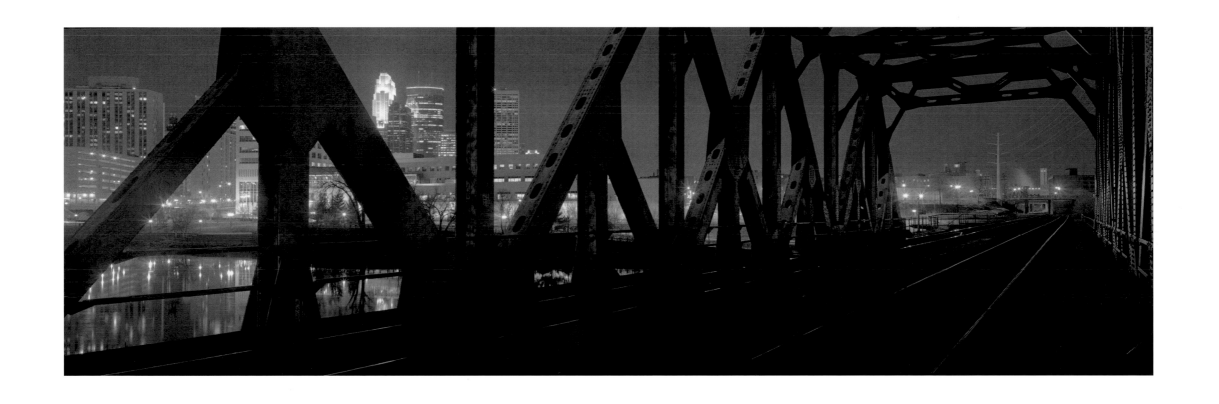

Plate 55. View of Downtown Minneapolis from Soo Line Bridge, Minneapolis, Minnesota, 2002

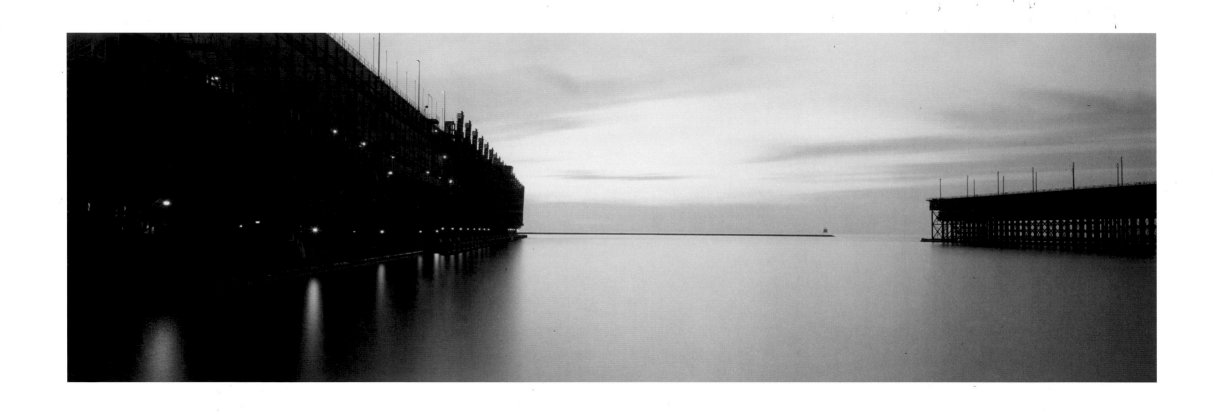

Plate 56. DM&IR Docks, Agate Bay, Two Harbors, Minnesota, 1994

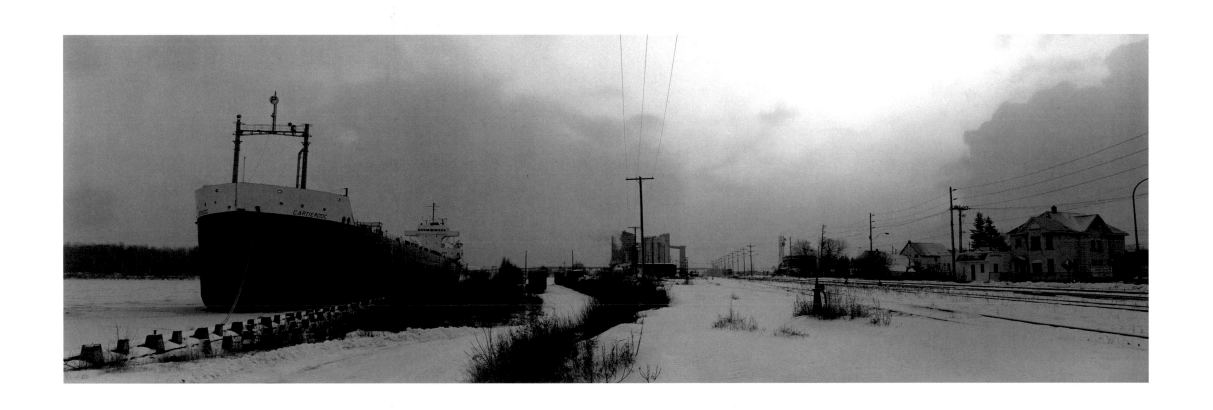

Plate 57. Dock Slip at Twilight, Thunder Bay, Ontario, 1994

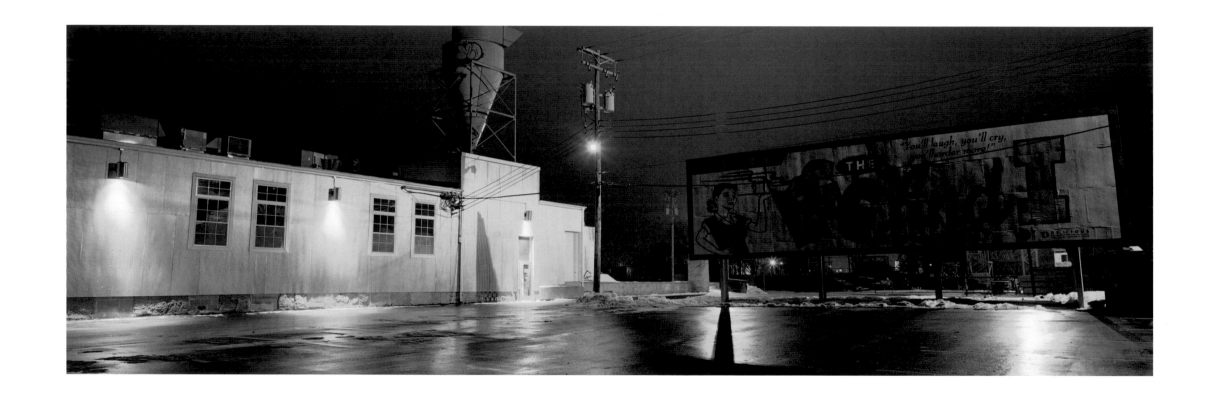

Plate 58. The Egg and I Parking Lot and Sign, Minneapolis, Minnesota, 2000

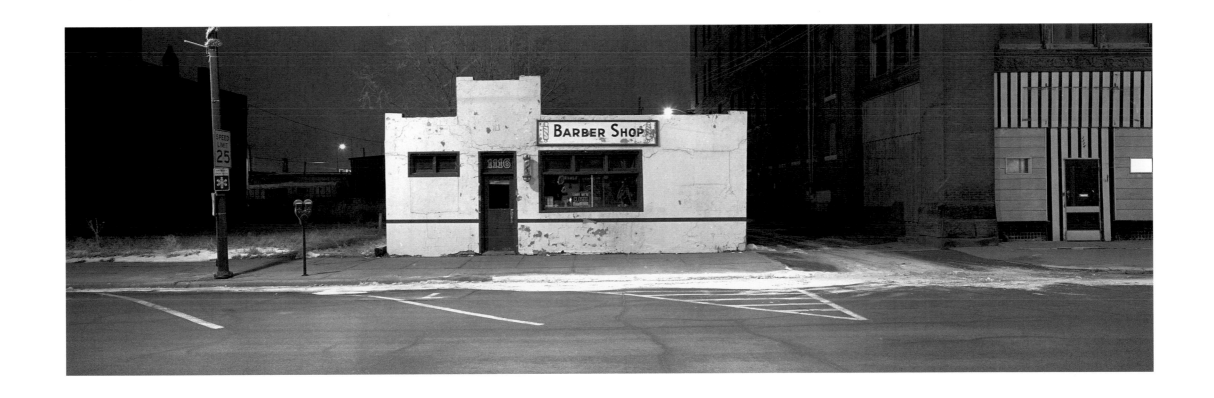

Plate 59. Barber Shop, Sioux City, Iowa, 1995

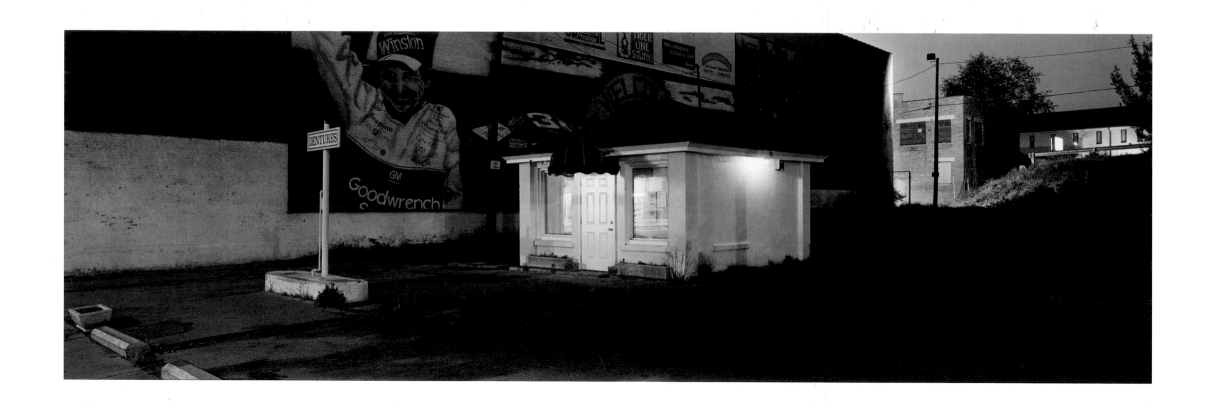

Plate 60. Denture Vendor in Former Parking Lot Booth, Bristol, Tennessee, 2002

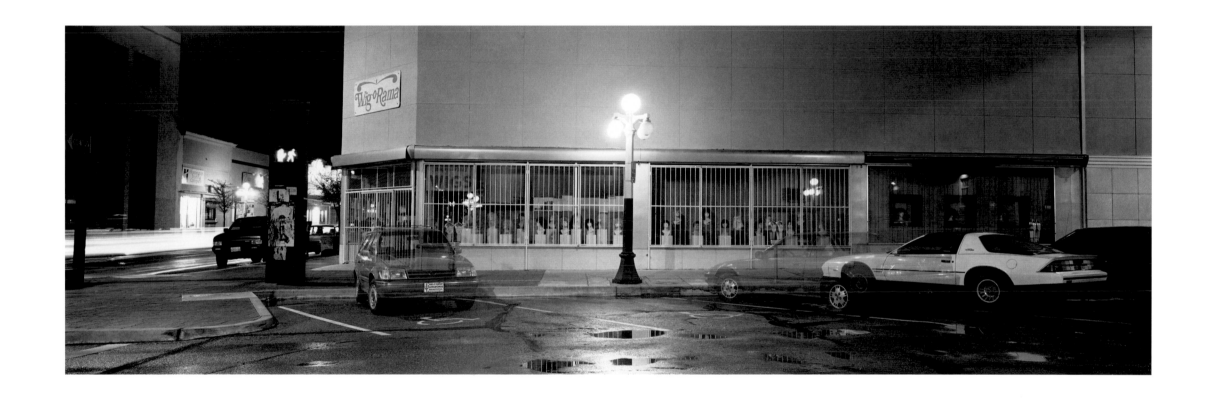

Plate 61. Wig-O-Rama, Tucson, Arizona, 1992

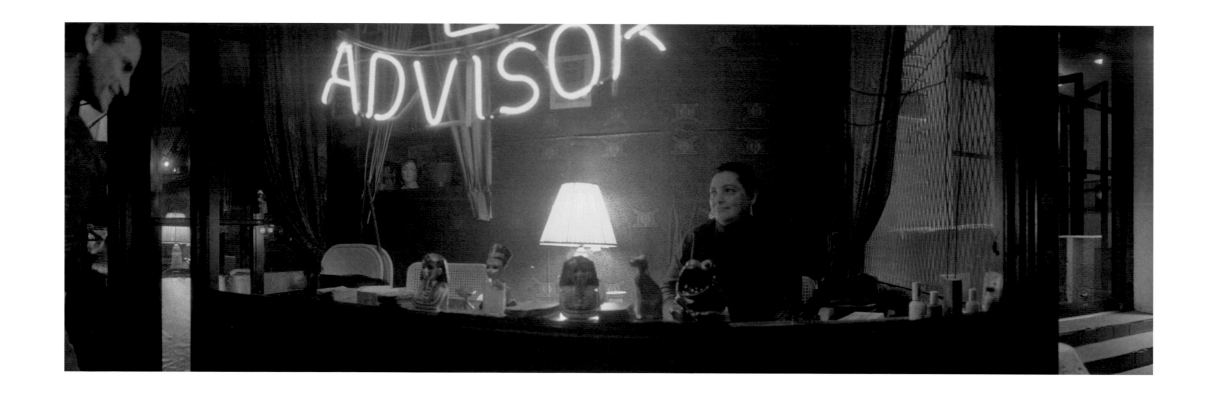

Plate 62. The Advisor, New York City, New York, 1996

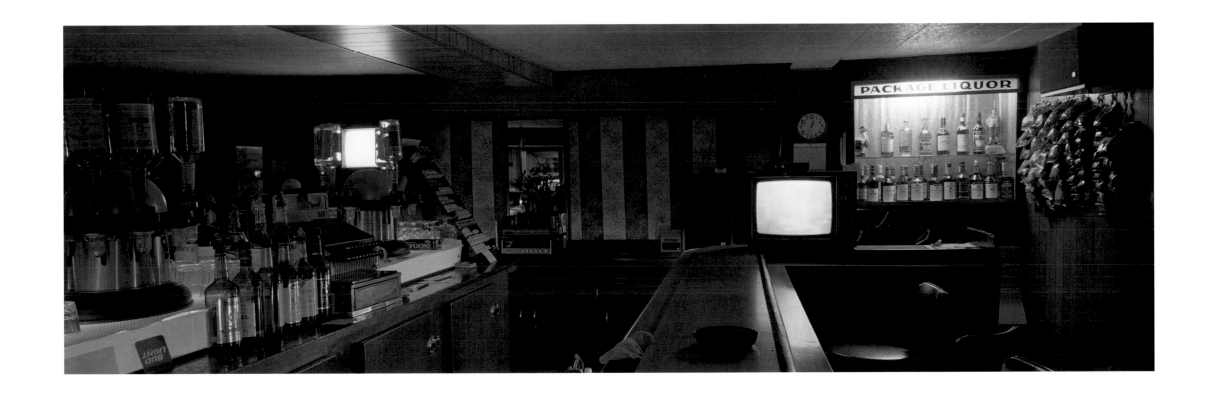

Plate 63. Inside Bar at Closing, La Crosse, Wisconsin, 1996

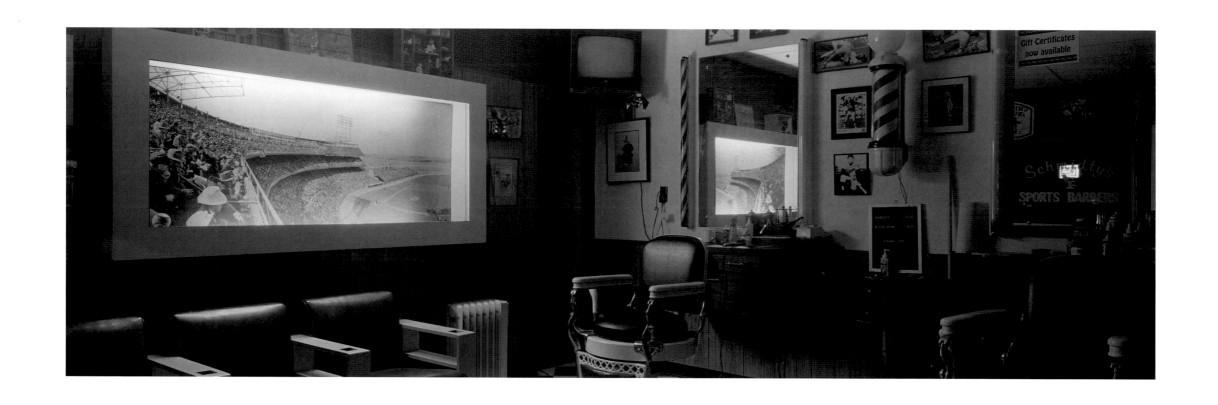

Plate 64. Inside Schmidty's Sports Barbers, St. Paul, Minnesota, 1995

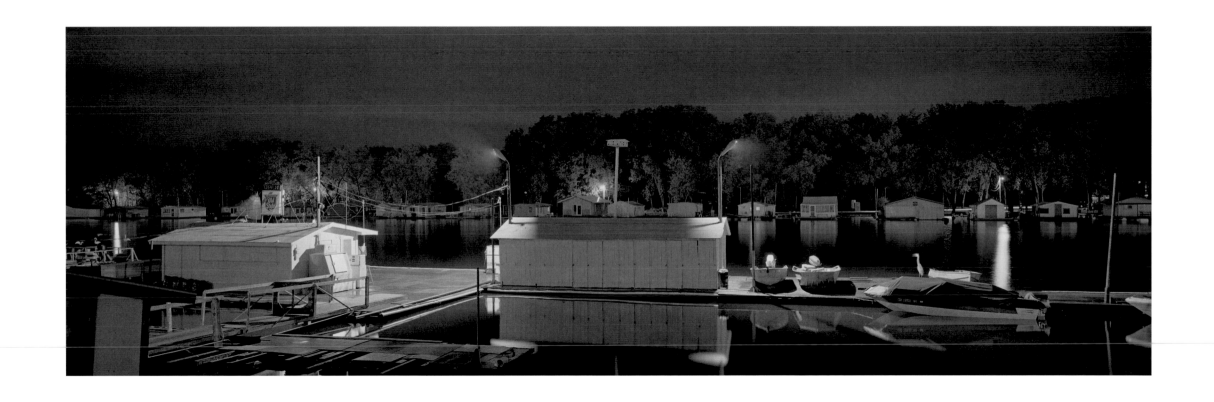

Plate 65. Bait Shop, French Island, La Crosse, Wisconsin, 1996

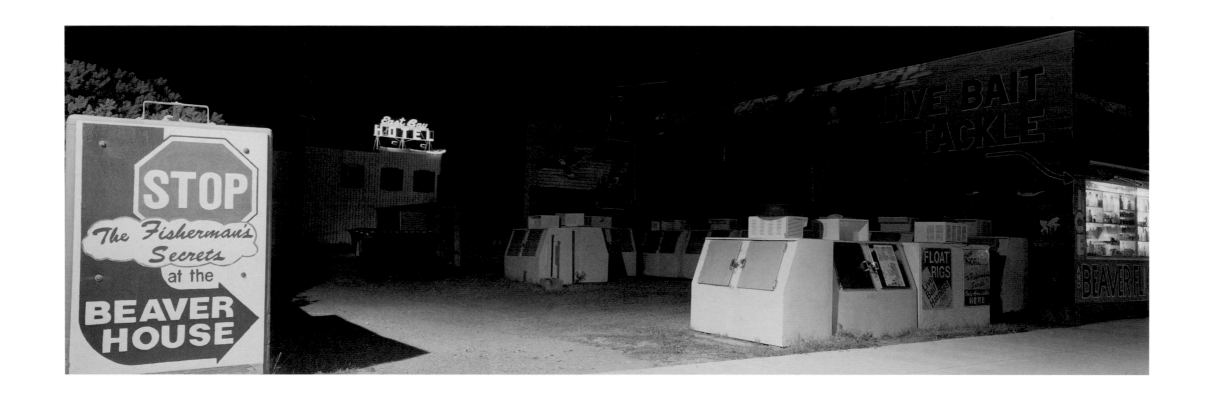

Plate 66. View of East Bay Hotel and Beaver House, Grand Marais, Minnesota, 2005

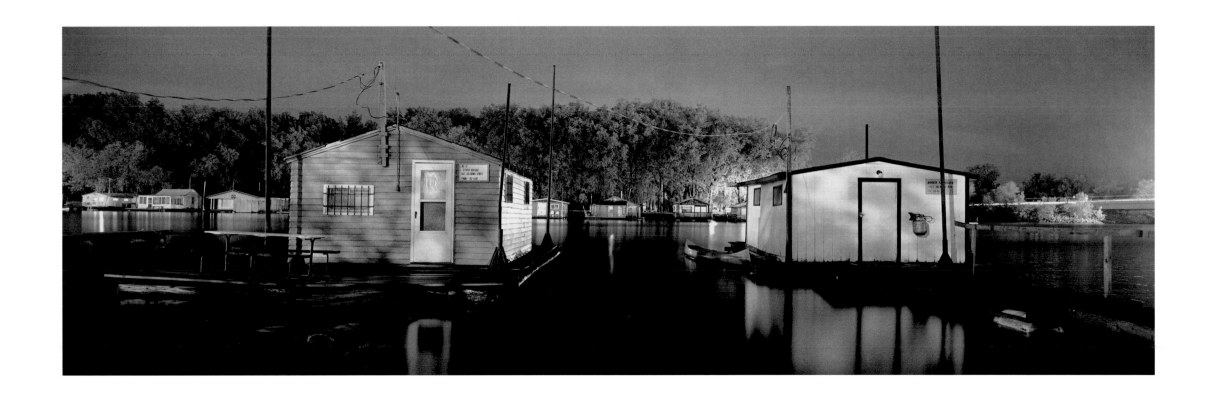

Plate 67. Houseboats, French Island, La Crosse, Wisconsin, 1996

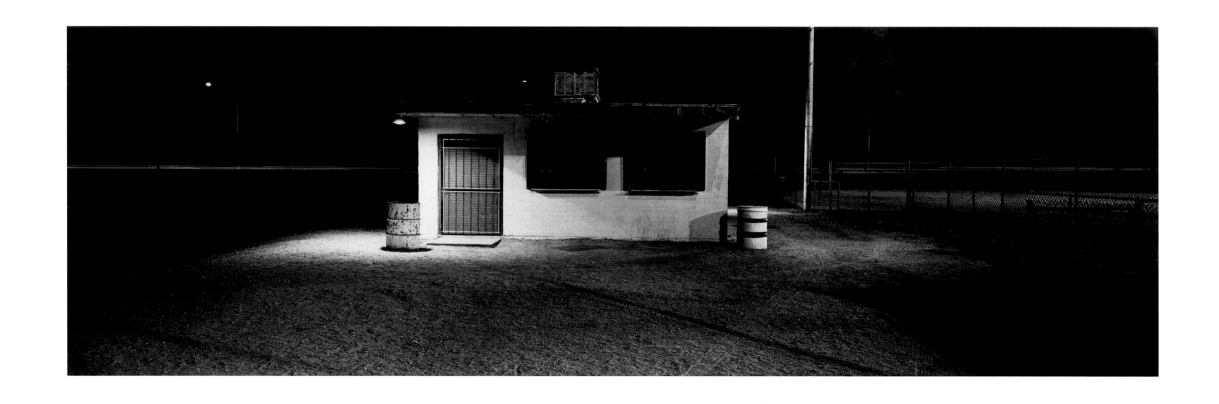

Plate 68. Service Building, Public Ballpark, Bullhead City, Arizona, 1997

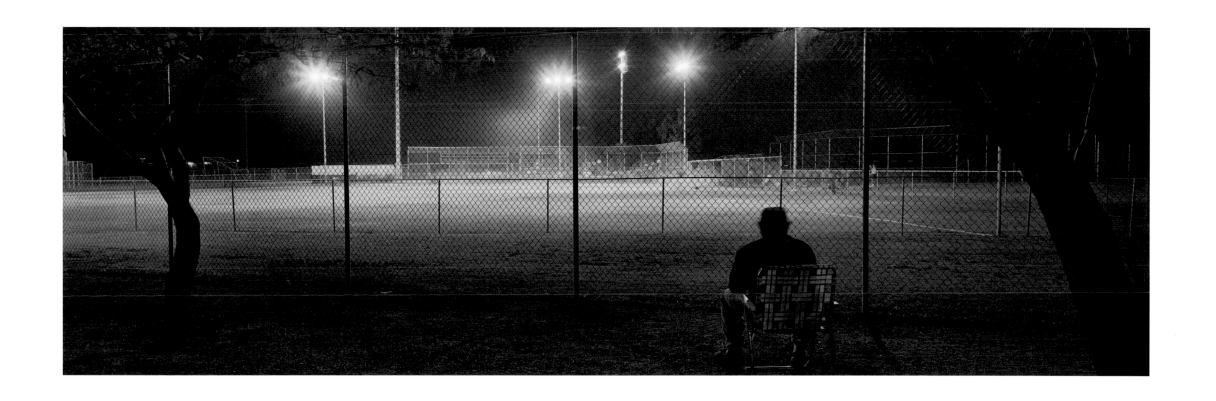

Plate 69. Grandpa Watching Granddaughter at Ballpark, Tucson, Arizona, 1998

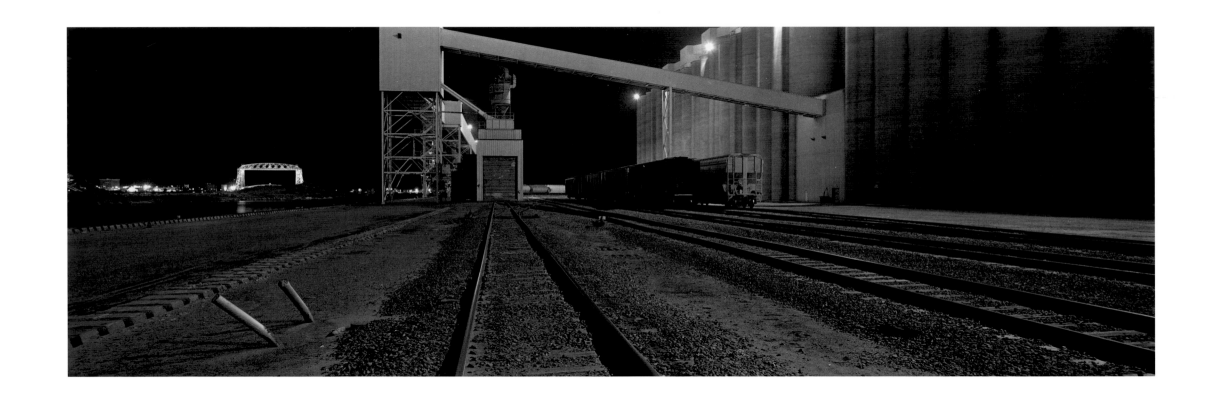

Plate 70. Cargill Elevator Site, Duluth, Minnesota, 1996

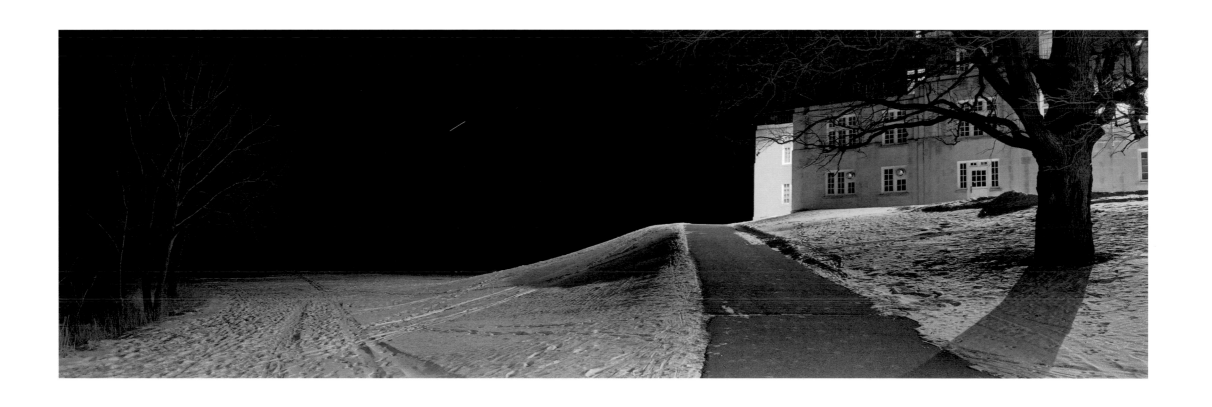

Plate 71. East End of Carleton College Campus, Northfield, Minnesota, 1999

Plate 72. Tree Detail, St. Paul, Minnesota, 1988

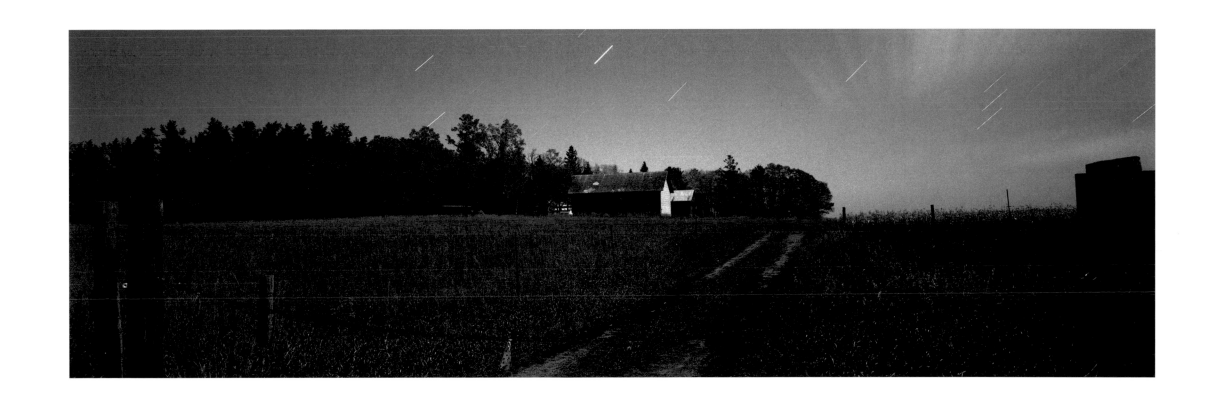

Plate 73. Farmstead in Full Moon, Park Rapids, Minnesota, 1992

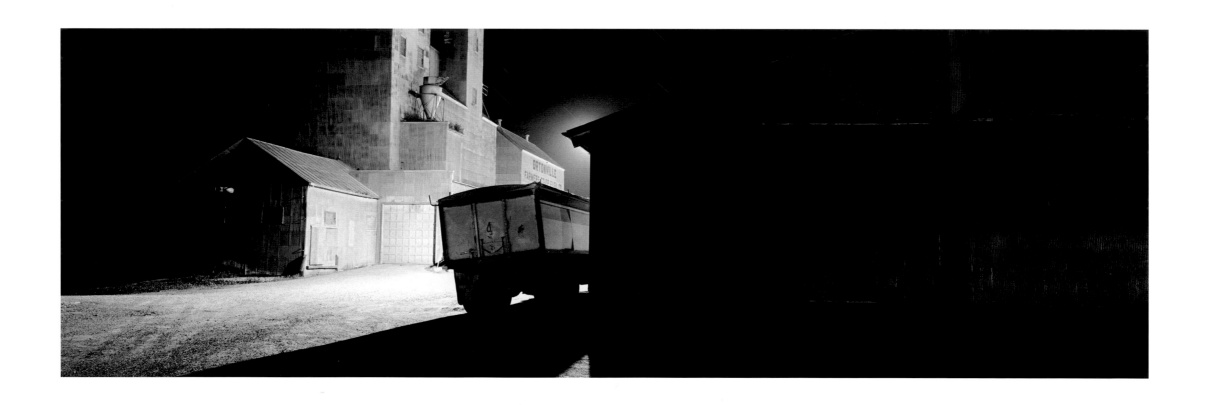

CHRIS FAUST

Photographer's Notes

Preface

My introduction to photography was actually through science. When I was an undergraduate I became enamored with macro-photography (the art of taking close-up pictures of small things), especially of insects, when I was working on a taxonomic key for classifying organisms. In graduate school, I became less interested in photography as a scientific tool and was increasingly driven to make photographs for personal expression, so much so that I changed my major from science to educational media. After college I was a medical photographer for a while, then worked in a graphics shop at the University of Minnesota. One day I decided to work on my own art. For several years I made images of children's landscapes (from ground level to three feet high) with a pinhole camera. It was good training: the pinhole format slowed me down and forced me to consider the composition and how the film might capture the image.

I began my panoramic work in an effort to view landscapes differently, just as I had done with the pinhole format. I started by making rotational montages and then graduated to the Cirkut camera. Before long, I was hooked, and I worked exclusively in this format. Very few photographers worked with panoramic formats then. When you entered the world of panoramics you found that everything is nonstandard, and you had to reconfigure darkrooms and commercial printing to accommodate this system. Panoramic photography is a little more popular today, and everything is easier with the scanning methods available now.

I didn't realize it at the time but my journey with night photography started with a local painter named Mike Lynch.

His paintings of everyday Minnesota scenes at night stuck in my head and resonated much later when I took up photography as an artistic endeavor. I would say that by day Mike and I are both attracted to cultural landscapes: rural scenes, cityscapes, the industrial sides of towns. But at night we are drawn to how the landscapes are illuminated by the subtle and beautiful tonalities of ambient light: a lone streetlight, the moon, light reflected off fresh snow, or the glow of a city.

For me the night work is mostly about looking at light in the manner of Edward Hopper or Mike Lynch, then translating it to film. In 1981 I attended a workshop with John Sexton, who showed me various techniques for compressing tonalities in lighting situations that were as extreme as one would find at night. I realized that my photographs could feel similar to Mike's night paintings, and I pursued my night work in earnest. Most of this work was made on road trips with friends or by myself when I had an out-of-town commission, but the majority of the images are from Minnesota and the Midwest. I usually did not have time for two- or three-week trips, so I just took a lot of shorter trips from my home in St. Paul.

Night photography offers a way to unwind after a day of concentrated daytime photography, with its sense of urgency as you look for those decisive moments. At night, it's a meditation of sorts, and the whole point is to take your time. I love the stillness and quiet while getting lost in my thoughts and the image that I am making.

The other part of photography for me is the craft of making negatives and prints. To "make a photograph" is still magical and soulful, very much like making music. The process of photography becomes an important part of the act of photography; I'm not just taking a picture. As I write this, I'm saddened by the rapid changes in silver-based photography. Many of my contemporaries are falling over themselves trying to achieve fine-art digital printing. I've been down this road and found it unsatisfying in comparison to traditional processes. I would rather stand by an enlarger in the darkroom than sit in front of a monitor with a mouse and keyboard—it's like being a trumpet player and being told that you can't play your horn anymore but instead will have to use a synthesizer.

Plate 1. Parked Truck, Ortonville Co-op, Ortonville, Minnesota, 1996

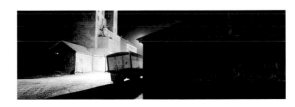

I made a series of photographs at this sleepy little elevator outside Ortonville, Minnesota, on Highway 12. The small grain truck parked to the side struck me as a scene from a Hopper painting. I positioned the glow from a streetlight right on the corner of the soffit of the pole barn just to flag it off. A dimmer, softer light across the road lit up the corrugated steel on the pole barn, giving the right side of the image a nice quality. Just enough ambient light strikes the galvanized steel on the pole barn to reveal an interesting texture. With the truck parked on a slight incline, the scene contains a certain energy that contrasts with the stillness of the night.

Plate 2. Bay City Milling, Winona, Minnesota, 1994

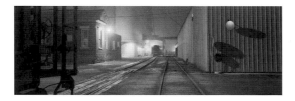

I was visiting family in Winona, Minnesota, and made this image the day before Christmas Eve. It was rather warm that year, and there was a fog from the river.

Plate 4. C&NW Snowplow, Worthington, Minnesota, 1994

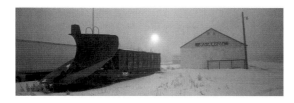

Fellow night photographer Mike Melman and I went to Worthington, Minnesota, for a weekend. Every time I see this image I imagine what it would be like to hitch up a locomotive, go out over the flat western Minnesota landscape, and actually use this plow.

Plate 6. Prop of the *Walter J. McCarthy Jr.*, Duluth, Minnesota, 1990

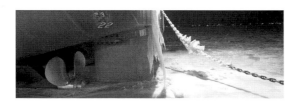

This image is the epitome of cold. It was –10° with a ten-mile-an-hour wind—not the coldest weather I've experienced while making photographs, but without a car close by it would have been too cold to stand out there for ten minutes to make this one. The Duluth Seaway Port Authority has a dock for maintenance and repair on various "lakers," as these freighters are called. The light casting down from the stern of the boat is just a streetlight that was cobbled together by the crew who worked on the boat during the winter, and there's another light on the con tower up front. The prop is out of the water because there's no cargo on board. Just as I made the exposure, a big sheet of ice from the bow of the *Edgar B. Speer*, another laker behind me, hit the lake. It scared the hell out of me—I almost jumped in the lake! I like the quality of light on the steel on the prop and the way the ice hangs on the chain; it reminds me of making sugar crystals on a piece of string in water when I was a kid. The ice has that kind of crystal quality.

Plate 8. Moonrise over Canal Park, Duluth, Minnesota, 1990

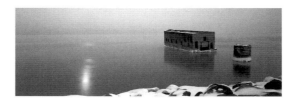

The concrete structure out in the bay was the old terminal warehouse before the canal was made into the harbor of Duluth. No longer in use, it has shifted and subsided. I thought it was an interesting form, especially with the reflection of the moon, which here had been up for about twenty minutes, so you see the reflection on the open lake. I'd always wanted to make an image of this dock, but all of the elements just hadn't been right before. The lake is open, with a slight wave activity that makes it look like ice. This is about a five-minute exposure. The light quality there is interesting at that time of the day. I like the glare that comes off the lake, the nice brightness of the snow, and the frosted ice around the concrete warehouse. I have tried to photograph it since, but as usual it's never the same when you try again. The shoreline has changed a bit, so the foreground elements are no longer there.

Plate 9. Ice Going out to Lake Superior, Duluth, Minnesota, 1990

This was an odd event. In the ship canal between Lake Superior and the Duluth harbor, a bunch of broken-up ice was going out into the lake. A long exposure made it appear to be a mysterious flow of something.

Plate 10. Boats Frozen in for the Winter, St. Paul, Minnesota, 1991

This image was made at the end of the famous 1991 Halloween blizzard in the Twin Cities. We had twenty-one inches of snow dumped on us in twenty-four hours. As you can imagine, nothing moved. Bored in my loft space in downtown St. Paul, I decided to go out for a walk and see what kind of photographs I could make. I made two or three that night. It was a hard go with all the snow—I had to hike about a mile to this spot. I didn't have snowshoes and could have used them at certain points. I like being out right after a major snowfall; the air is sort of wet and you hear the drone of snowblowers and the sound of snowplows scraping the pavement. In this image, I like how it looks like we're on a parking lot rather than a river: it's a nice flat surface with all this snow sitting on top of it.

Plate 12. Grilling and Ice Fishing, Leech Lake, Minnesota, 1996

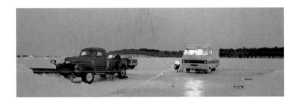

I made this image on one of my trips to Leech Lake to explore the annual Eelpout Festival. Every state has certain male rituals that crop up as a result of guys having too much time on their hands, and this festival is one of them. Thousands of ice-fishing enthusiasts go out on Leech Lake the third weekend in February to catch as many eelpouts as they can. The eelpout (technically, the freshwater burbot) is a bottom-feeding scavenger whose meat tastes like the bottom it came from. If you've been spoiled by the taste of walleye, you would not look forward to a dinner of eelpout. The activity at this festival can be likened to the buffalo shoots of the 1800s, with hundreds of eelpout carcasses littering the ice.

Nevertheless, one does work up an appetite in the cold air, so many resort to grilling various cuts of the bovine. I found this scene very interesting. There was the classic row of tip-ups off to the right; a vintage pickup with a plow; and last but not least the "Winnie." The grill was being readied with a nice fire to get the coals going. I had just started making my exposure when a woman came out of the camper and walked over to me with her flashlight on. I could have covered the lens but I wanted to see what the flashlight would look like on film. She asked me the usual question: "What are you taking a picture of?" I said, "Why, you, of course." She could not see what was so interesting about that, so I let her look through the finder and then she sort of got it. I often wonder whether people might appreciate my work more if they could view the scenes as Polaroids.

Plate 13. Poutological Research Center, Eelpout Festival, Leech Lake, Minnesota, 1996

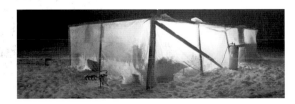

During the same trip as the *Grilling and Ice Fishing* image, I came across this structure made from two-by-fours, ice augured and frozen in with slush as mortar. The walls and roof were made with liberal amounts of poly stapled to the wood. There was quite a ruckus inside so I went in to see what was up. Along with the usual flowing of beer, there were various pseudoscientific charts and graphs on the walls that measured relationships like beers drunk versus eelpout caught. After I talked to the men here I found out they worked for the Minnesota Department of Natural Resources, and one guy was a biology professor at Bemidji State University.

Plate 18. Dairy Queen Entrance Light, Watertown, South Dakota, 1997

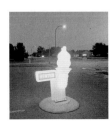

For me, like most kids when I was growing up, the DQ was *the* destination on our bikes. Our DQ never had fancy entrance signs like this, though. I just had to make a photograph of this piece of commercial archaeology.

Plate 19. Old Gas Station, Sioux City, Iowa, 1995

Sioux City is an interesting town, and I made quite a lot of images there. It's undergoing transition from farm industries to a manufacturing and service economy, and transitional landscapes are fertile ground for images. When I was making this one, I noticed a homeless guy standing and watching me the whole time. He never said anything, and when I moved he kept his distance but followed me around. This was one of the few times that I was ever creeped out while making night photographs.

Plate 20. Gas Station, Magdalena, New Mexico, 1992

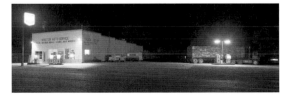

My friend Dan and I spent the night in Magdalena after an incredible day at the Very Large Array at the National Radio Astronomy Observatory between Magdalena and Socorro. I like this image for the same reasons I like *Parked Truck* from Ortonville, Minnesota.

Plate 21. Waiting at the Crossing, Lincoln, Nebraska, 1993

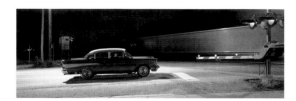

I made this photograph the night my friend Frank and I went out with friends for dinner. On our drive back to the house the signal went down for the crossing to let a unit train full of coal pass. We were all laughing and having a good time in the car, about three cars back from this '57 Chevy. I looked up at the Chevy and all of a sudden realized that there was a photograph, and I popped the trunk. I had no film in the camera. Because the train was going full speed I had about two minutes, tops, to get out the camera, load it, and set it up. Everybody was asking what I was doing, and I said, "There's a photograph up there!" While I was making the picture, the couple inside the car rolled down the window and asked, "What are you taking a picture of?" I responded, "You." They wanted to know if they should smile.

Some people call it coincidence, others call it, I don't know, just luck, but I'd like to think there's a little divine intervention in this work. The photo gods tap you on the shoulder and say, "By the way, there's a picture right here, and you'd better make it." There is something to be said for being in the right place at the right time, but you also have to see it. Photographs have gotten away because I just missed them, and others kind of fall into your lap. This is one of those.

Plate 23. City Park, with Water Cannon Target and View of Casino, Bullhead City, Arizona, 1997

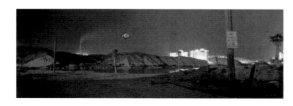

This was such an odd scene: a water cannon target made from a beer keg with a huge casino in the background on the banks of the Colorado River.

Plate 25. Lake Powell at Midnight and Full Moon, near Page, Arizona, 1996

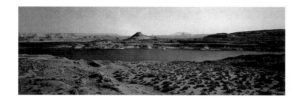

A road goes over Glen Canyon Dam at Lake Powell. From the west side of that dam, I saw a spot where I could pull over and walk out as far as I could go. That's where I made this image. I sat down and made a twenty-minute exposure. It was absolutely calm and kind of eerie. There was no noise, not even crickets. I could hear my heart beat. I have never been outdoors and not been able to hear something. Even with this much seemingly intense light, the full moon was not enough for the film, and it's a difficult negative to print. Maybe I should have given it more development in a "pushing" process rather than my usual compensation process. When it's printed right, it looks good. I like the texture of the sagebrush and the smooth lake, and the sky has a nice tone.

Plate 27. Gravel Conveyor, Shiely Yard "A," St. Paul, Minnesota, 1991

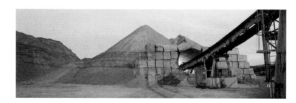

This gravel pile had an unearthly glow from the light at the end of the conveyor. I miss the old Shiely gravel company—they were cool about allowing people on the site, and they used to let artists go on the gravel barges up and down the river, which was always inspirational for this landscape photographer.

Plate 29. Cut Elevator Bin, GTA Demolition, St. Paul, Minnesota, 1989

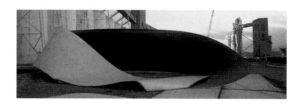

This was one of my first personal projects. I photographed the demolition of the Grain Terminal Association site on the river near downtown St. Paul. It was unusual in that all 120 bins were made of plate steel, which created very interesting images as the demolition company cut them up. A cold front moved through town the night before with high wind, which collapsed this metal bin.

Plate 31. Pallet and Keg Yard, Old Style Brewery, La Crosse, Wisconsin, 1996

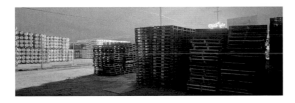

After a hard night of making photos, the keg yard reminded me that a tall cool one would taste good. I didn't have an Old Style, though—I had a "Leinie."

Plate 35. View of Gold Medal Flour Site from under Stone Arch Bridge, Minneapolis, Minnesota, 2002

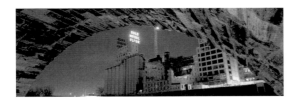

This site was the heart of the milling district in Minneapolis. I liked this view from under the arch of another historic site, the Stone Arch Bridge. After I set up and started the exposure, a couple of drunk guys were above me on the pedestrian walk. They stopped and continued talking. All of a sudden I felt something wet. I looked up and a guy was urinating on me. "Hey!" I yelled. "I'm down here!" "Oh, I didn't see you, man!" he yelled back.

Plate 37. View of Downtown Minneapolis from Base of Stone Arch Bridge, Minneapolis, Minnesota, 2002

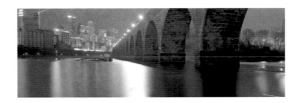

I have fallen in love with this whole area near the Mississippi River at night. I hadn't explored it much before, even though it's in my backyard. I didn't know it at the time, but the morning before I shot this a guy had been robbed and killed less than a mile away on Nicollet Island. Usually I don't feel vulnerable when I photograph at night, but when I took this I was very uncomfortable, I guess because of the hum from the University of Minnesota heating plant behind me, up the riverbank I'd descended. It was a cold morning before Christmas, about 5:00. Nobody was around, not even in the park on the top of the bank. No one could hear or see me down below. This strong view of the bridge was worth overcoming my jitters.

Plate 39. Memorial Stadium Demolition, University of Minnesota Campus, Minneapolis, Minnesota, 1993

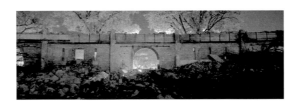

The University of Minnesota built Memorial Stadium after World War I and pledged in an inscription over the main entrance that it would remain standing in memorial. Well, I had to photograph it before it was all hauled away and a new natatorium put up in its place. I like the tonality of the light coming through the fall leaves and the arch. The inscription was saved and placed in the university's new alumni center.

Plate 40. Christmas Light Display, Longfellow Neighborhood, Minneapolis, Minnesota, 2001

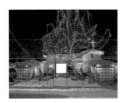

This particular display is a famous tradition in a neighborhood in south Minneapolis. There is a projection TV in the white box but because of the continuous moving image and the length of the exposure it appears white. The fact that the screen replaces a crèche does it for me. I have been informed that the house has been sold, so it's likely that this is a final note on this display.

Plate 41. After a March Storm, St. Paul, Minnesota, 1988

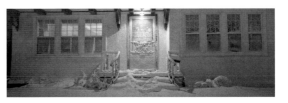

This image represents the first negative I made with my camera. I had mail-ordered it, and it arrived via UPS. The boys in brown have always been a little casual about their delivery. I was working all day and of course the deliveryman decided to leave the package in the Weber grill in the back. He left a sign on the screen door: "package in grill."

Plate 42. Alley Detail between Garages, St. Paul, Minnesota, 2000

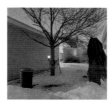

I have always been fascinated with the alley. We seem to present our best side in the front yard, but the backyard and alley expose the real character of the residents. This is the alley in back of my house: a typical alley with a fresh dusting of February snow.

Plate 43. Garage Detail, Albert Avenue, St. Paul, Minnesota, 2000

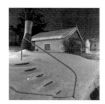

I've driven by this garage in all seasons of the year. This view in the winter holds the most mystery for me. The aluminum on the tree trunk is for squirrel protection (I asked the old man who lives there). A bird feeder is outside the frame. The squirrels figured out how to get in the tree, and then it was easy to get to the feeder.

Plate 46. House on the Edge of Town, Worthington, Minnesota, 1994

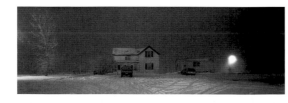

Mike Melman and I spent a long weekend in Worthington and Pipestone in southwestern Minnesota. We got up about 4:30 A.M.

and went out to make pictures. Next to the old C&NW rail yard I found a home lit with two streetlights. It looked like a couple of single guys lived there. The snow outside the houses was completely packed with snowmobile tracks. It felt so Minnesota.

Plate 47. Christmas Morning, Nicollet, Minnesota, 1989

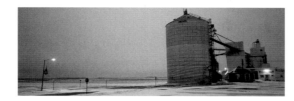

One Christmas morning when everyone was still asleep, I went out to see if there were any photos to be made. I found this scene in Nicollet, Minnesota. I loved the lone ornament on the light pole and the feeling of the edge of town as the granary separates the town from the fields beyond.

Plate 51. General Mills Elevator Detail and Bend-Tech Plant, Duluth, Minnesota, 1996

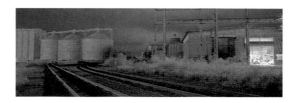

My friend Andy and I spent the night in Duluth after making negs all day while inching our way up north on the back roads. Photographs are never on the freeways. We ate and went down to the Duluth seaport. No freighters or lakers were docked, so on the way back we stopped at the Bend-Tech facility and made some images. I like this view looking into the production area with the General Mills grain bins in the background.

Plate 52. *Peter Misener*, Thunder Bay, Ontario, 1994

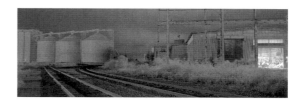

I went to Canada with my friend Mike Melman. He only likes to photograph in the winter on cold mornings or late evenings, so this was the right place to be. I like the scale differences between the elevators on either side of the laker docked there. The laker looks tiny, though it isn't. I thought for sure that when I finished this ten-minute exposure the ship would blur because the lake always has some sort of swell; I thought the boat would bob up and down. Instead the lake was absolutely calm and the boat is actually tack-sharp. I'm on the edge of this dock. Each elevator is run by a Canadian province that ships in the grain. So there's a Manitoba elevator, a Saskatchewan elevator, and then other elevators that are privately owned. I thought that the Canadians would kick us out of there, but they weren't all that concerned, even though we had to jump a fence to get in.

Plate 53. Bayfront Marine Tanker Truck, Duluth, Minnesota, 1990

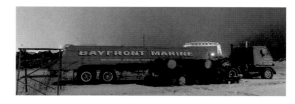

Someone could do a series on the Aerial Lift Bridge in Duluth, similar to what Joel Meyerowitz did with the St. Louis Arch. I have a good start with this image and *Cargill Elevator Site* (Plate 70).

Plate 56. DM&IR Docks, Agate Bay, Two Harbors, Minnesota, 1994

These docks have been here since mining started on the Iron Range. They are made of wood and metal. Semi-organic-looking forms go out onto this lake with the big ore boats. Each hopper car goes out and dumps its load into the giant hopper that has these little raceways that come down and dump into the hold of the boat. Taconite pellets are all over the place—it's like walking on ball bearings. This is an odd place. The day I took this photograph, my friend Mike and I were definitely trespassing. We went around a small spot in a fence and made a nice bunch of pictures. After that I went back up by the switchyard to photograph steaming ore cars with hot taconite getting ready to be loaded into the hoppers at the end of the dock. All ten locomotives were idling there. I was getting set to make the exposure when a yard boss came up behind me and tapped me on the shoulder. I jumped in total surprise. He said, "I'm afraid I'm going to have to ask you to leave." I obliged him and moved on without making the photograph.

Plate 58. The Egg and I Parking Lot and Sign, Minneapolis, Minnesota, 2000

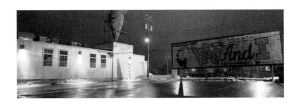

This image was the result of an interview for Minnesota Public Radio. I met the reporter Mary Stucky at The Egg and I (a popular breakfast spot), and we tried to think of urban images. As the tape was rolling I looked up and saw this scene and made a neg. I made two others that session, but the first one was the one.

Plate 60. Denture Vendor in Former Parking Lot Booth, Bristol, Tennessee, 2002

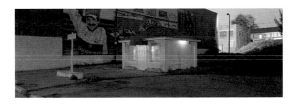

We were out driving and making photographs all day. Our group got a hotel and decided to get something to eat. We drove back a different way, and then I saw this odd vendor in a parking lot in Bristol, Tennessee. I especially liked the juxtaposition of the denture sign under Dale Earnhardt's armpit. I don't know if I would buy any dentures from this guy—it's a strange place for someone selling dentures. I can't believe people buy their dentures in Bristol, Tennessee, at a small shack in the middle of a parking lot.

Plate 61. Wig-O-Rama, Tucson, Arizona, 1992

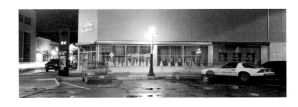

At first glance I was struck by the weird nature of this retail store downtown selling wigs with such cavalier signage. The ghost cars were parked before I started the exposure but at various points left the frame.

Plate 62. The Advisor, New York City, New York, 1996

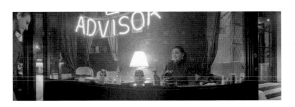

I was in New York City visiting my friends Cheryl and Allen. We had some Indian food and on our way back to their home in SoHo we passed this lone fortune-teller sitting behind this glass atrium. Another friend, David (the disembodied head on the left), talked to her, half-interested in getting a fortune but then he backed out. This is one of the few Widelux images I have made of street scenes, and it is not developed in my usual compensation process.

Plate 63. Inside Bar at Closing, La Crosse, Wisconsin, 1996

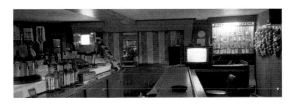

My friend Andy and I decided to have a cool one after a night of doing some images in La Crosse. We closed the bar in true Wisconsin fashion (our hotel was next door so we didn't have to drive).

Plate 65. Bait Shop, French Island, La Crosse, Wisconsin, 1996

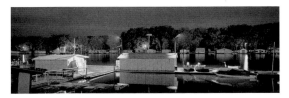

A channel diverts the Black River around French Island in the Mississippi River and creates a sort of backwater where these

boathouses and bait shop are. I was with a buddy of mine, Andy, photographing in La Crosse. I was drawn here because it's such a typical Wisconsin river scene that portrays a culture on this part of the Mississippi. I really liked the way the bait shop and boathouses played off each other. I was concerned that the heron would bolt and fly away, but he didn't. He just stayed there for the entire exposure.

Plate 66. View of East Bay Hotel and Beaver House, Grand Marais, Minnesota, 2005

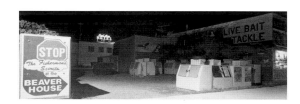

These two landmarks on the North Shore of Lake Superior have been a part of my memory since I was a boy. I found out the last time I visited that the original East Bay Hotel was set for demolition, so I made a group of photographs to remember the essence of the place. I like the Beaver House as well (an eclectic store selling bait and tackle, licenses, and permits). The vast sum of ice machines in the back is quite unusual.

Plate 67. Houseboats, French Island, La Crosse, Wisconsin, 1996

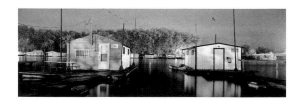

I admit it: I'm obsessed with boathouse culture on the river. Nobody pays taxes; utilities are spotty. And until recently there were sanitary and potable water concerns. Rustic, to say the least. But some people have figured out all the problems and live full-time there. The state DNRs in Minnesota and Wisconsin were trying to shut them all down, but this policy is now on hold. These houseboats are on French Island, where the Black River and the Mississippi River meet—on the edge of the town so there are plenty of streetlights, but it still has the look of the edge.

Plate 69. Grandpa Watching Granddaughter at Ballpark, Tucson, Arizona, 1998

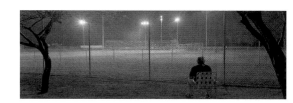

This was in March, about 8:00 at night. A buddy and I were going out and getting some food for the next morning, and I had the camera in the truck. All of a sudden we saw this guy sitting in a lawn chair outside this huge cyclone fence outside this ball field off Speedway Boulevard. I just had to know what this was all about. I started making a photograph and then asked him why he was sitting outside the ball field. He said, "Well, my granddaughter is playing softball and she gets very nervous when I'm watching her, so I watch her from out here." Because the exposure is too long, you don't see the kids running around on the field; they're running so fast that on the neg all you see is a haze. I didn't want this guy to move too much because then he would have been completely blurry, and he obliged me. I like the way the eye plays between the ball field and the guy watching the ball field. This is another gift from the photo gods: you have to be aware and look for images, and suddenly they appear. Like the bumper sticker that says "Start Seeing Motorcycles," there should be one that says "Start Seeing Photographs."

Plate 70. Cargill Elevator Site, Duluth, Minnesota, 1996

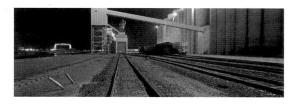

This image was made on another field trip to Duluth with my friend Andy. I don't think I'd be able to make this picture again after 9/11, which is probably true for many of my images. Security on all industrial sites has been ramped up, especially near trains and seaports. Like geography, politics keep changing, too. I walked around this site for about an hour with no one challenging my presence. I like the small but familiar image of the Lift Bridge in the background.

Plate 72. Tree Detail, St. Paul, Minnesota, 1988

This scene reminded me so much of images by Michael Kenna I've seen over the years: the wind blowing the trees around at night with other light sources lighting them up.

Plate 73. Farmstead in Full Moon, Park Rapids, Minnesota, 1992

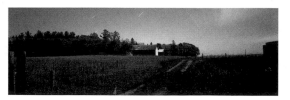

This image was done with a full moon overhead. The streaks in the sky (which also appear in Plate 71) are high cirrus clouds passing in front of the moon.

Acknowledgments

This book, like all books, is an effort that starts years before it's done, and is accomplished with much help from many people.

Of course great thanks go to my family. My wife, Diane Rumsey, has endured my near obsession with all things photographic. She has been an anchor that keeps me from drifting too far. My son, Chad, has grown up in the studio and has been a trooper about being involuntarily dragged along on many photographic outings.

My parents, Charles and Helen Faust, have always been supportive of my endeavors. They have been there for me throughout all projects, large and small, and certainly this publication is for them. My siblings, Lisa, Maria, and Matt, have also been supportive of me and of each other, and this book is for them, too.

A special thanks to my photographer friends who have joined me on many road trips—Mike Melman, Andy Baugnet, Dan Dennehy, Martin Berg, and Ted Haaland. Mike was on a lot of the trips represented by photographs in this book. He liked early mornings in winter only, and I was just about the only other crazy guy that would get up on a winter morning and make photographs. We were a good match. Ted also merits special thanks: not only is he my brother-in-law but he introduced me to the road trip. We started our road trips together back in the 1980s. I credit Ted with getting me going in a serious way on my personal work.

I want to thank others in the fields of fine art and photography who always encouraged me. The endeavor of fine art photography is in special need of encouragement, because truly many are called and few are chosen. Among the chosen are Cheryl Younger, Bonnie Wilson, George Slade, and Sid Kaplan, whose saying "everything's there but the picture" is a phrase that I always remember.

In 1981 I took a photography workshop with John Sexton. At that point I realized the possibility that I could make negatives that would approximate how I wanted my night scenes to look. I also discovered that an accomplished photographer such as John could be gracious and supportive; he encouraged every photographer to do his or her best work. That can be rare in this field.

Certainly two other men have been pivotal at various points in my process: Mike Lynch and Frank Martin. Seeing Mike's work when I wasn't really into photography had such an influence on my vision of landscape and how I interpreted it that I don't know what my landscape photographs would be like now if I hadn't seen his paintings first. When I met Frank Martin in 1990 we agreed to embark on a six-year project of photographing suburban development throughout the Midwestern and Western United States. Frank was the writer and I was the photographer, and together we met many people. We received several grants and learned so much that it's hard to estimate the huge impact this project had on my work.

Some people who helped me are no longer with us. Ed Bardill, one of my photography professors at the University of Wisconsin, La Crosse, was a product of photography during his time in the service, a kind of "f8 and be there" sensibility. He liked the work I was doing and gave me a key to the school darkroom, which meant I could go in anytime and print—and I did. Ken Jandel took a chance on a newbie like me and in his ex-marine corpsman style "trained" me into medical photography. God bless him—he had a way with surgeons like I'm sure he had a way with certain master sergeants. Gus Gustafson, the unofficial mayor of St. Paul and the eternal optimist, was the Norman Vincent Peale of photography; whenever I was down about the business, he would say "ah, no problem," and whenever I had a question about what I would charge for some work he would say "just bill 'em." Gus out and about was always a good sign. The other eternal optimist was Jim Czarniecki. Interested in what I was up to, he always had new ideas, and he was like that with many artists. He will be missed, as will my incredible color printer, Jeff Gary. He printed by intuition, and now that I've been forced to print color with Photoshop I realize how good he was.

I would like to thank everyone at the University of Minnesota Press for taking on this book. Todd Orjala was particularly helpful and kept things rolling.

Many people and trips have blessed me over the years. The photo gods have smiled on my work and I'm greatly appreciative.

Chris Faust has received numerous honors for his photography, including three McKnight Foundation Fellowships for Photography and a Bush Fellowship. In 2000 he and artist Mike Lynch had a joint exhibition, *Night / Photographs,* at The Minneapolis Institute of Arts.

Joan Rothfuss is former curator of the permanent collection at the Walker Art Center in Minneapolis, where she curated numerous exhibitions, including *Past Things and Present: Jasper Johns since 1983.*